LIVERPOOL
IN THE HEADLINES

Daniel K. Longman

AMBERLEY

Thank you to Keith Samuels, Greg Skipworth and Seamus Rush

First published 2016

Amberley Publishing
The Hill, Stroud
Gloucestershire, GL5 4EP

www.amberley-books.com

British Library Cataloguing in Publication Data.
A catalogue record for this book is available from the British Library.

ISBN 978 1 4456 4886 6 (print)
ISBN 978 1 4456 4887 3 (ebook)

Typesetting and Origination by Amberley Publishing.
– Printed in the UK.

Introduction

As a lifelong Merseysider I have witnessed a veritable hodgepodge of news stories emanate from these shores. For the past twenty-seven years I have seen success and celebrations, tragedy and heartache, buildings soar, demolition ensue and substantial change embrace the entire region. I have observed victories on the pitch and protests in the streets. I have witnessed royalty stop by, theatres reborn and whole shopping districts transform the urban landscape. I have seen huge ships sail on the Mersey, festivals and parties galore. I have seen giants walk amongst us and hotels, restaurants, museums and galleries welcome millions of visitors who descend upon this coastal hotspot from every corner of the globe. I have seen all this and so much more in just one metaphorical blink of existence.

It is clear that in 800 years of life this city has never been shy in coming forward with an interesting tale or two, and it is now after much digging and exploration that I present to you *Liverpool in the Headlines*. This book is a modest compilation of historical news stories to be found within the local archives. It has been a particularly difficult publication to create due to the sheer number of newsworthy events from around these parts and the frustratingly limited space between these pages. I also discovered that a number of stories you would expect to make headline news just didn't feature in the early editions of the city media. Nevertheless I hope my selection at the very least provides a stimulating overview of the character of Liverpool, its history and of course its people, who without question hold a genuine love for their city's rich heritage. Spelling mistakes within the newspaper content have been left in to keep the text as historically accurate as possible. The headlines reveal many aspects of Liverpool, but what has stood out during the course of my research is a very singular sense of hope and resilience. The city has undoubtedly been through some tough times this past century but the strong spirit of its people has consistently shone even in the darkest of hours. It is this resolute passion and unwavering self-belief which has brought something of a twenty-first-century renaissance of late, and Liverpool is now once again a true destination to behold. Who knows what the headlines of the future shall be, but I have a quiet suspicion that whatever the story, Liverpool will continue to flourish in its own special and unique way.

Daniel K. Longman

On 27 October 1879 the *Liverpool Echo* was published as a cheaper sister paper to the *Liverpool Daily Post*. Eagle-eyed reporters were originally based at the firm's office in Victoria Street.

27th October 1879

A PAPER IS BORN

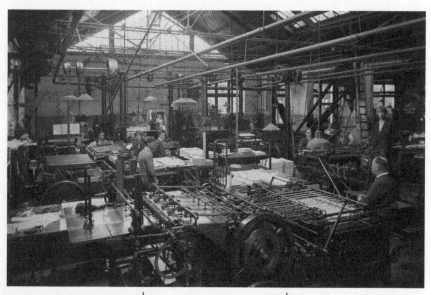

An Evening Paper is now a universally appreciated luxury, if not necessity, of town life, and if properly worked succeeds in conveying the news even into country districts with such clarity and promptitude as to create quite a new interest in public events. It is not necessary therefore for the *Liverpool Echo* to prove its right to exist. The most that read be done on this occasion is to give us a assurance of the efficiency with which the new journal will fulfil its functions. These are various. An evening newspaper, fulfilling a less responsible place then that of a morning newspaper, and intended to meet the wants of a more chatty and leisured part of the da, will naturally aim at presenting so much of the day's intelligence as is common to both in a lighter and more entertaining manner. And of necessity much news as arrives during the day must be given with a pithiness that will please many tastes. The resources of telegraphy, however, and the speed with which they are utilised, enables an evening paper to bring almost to the moment occurrences of the passing hours, and after all it is in the day and not in the night that majority of reportable events occur.

Liverpool was granted its Royal Charter in 1207, but it took almost 700 years to achieve city status. This once humble fishing village has grown to become one of the world's leading destinations.

12th May 1880, liverpool Echo

LIVERPOOL A CITY

Letters Patent Sealed

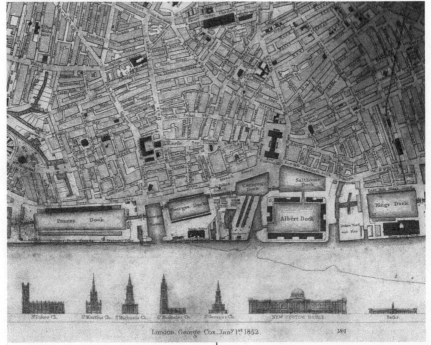

Liverpool is no longer "a town;" it is to-day a "city." This morning the Town clerk received a letter from the Home Office stating that the letters patent constituting Liverpool a City had been sealed and dated yesterday. The documents are expected to-day, but they take effect from yesterday, according to their date.

The Mersey Railway was opened on 20 January 1886 connecting the communities of Wirral and Liverpool. Although initially popular, the polluted atmosphere of the tunnel forced passengers to revert back to the ferries until electrification of the line in 1903 revived the railway as a viable mode of transport.

21st January 1886

THE MERSEY RAILWAY

An event of vast importance, not only to Liverpool and Birkenhead, but to the whole of Lancashire, Cheshire, and North Wales, took place yesterday, when his Royal Highness the Prince of Wales, in the presence of a vast concourse of citizens of Liverpool, formally declared the Mersey Tunney open for public traffic.

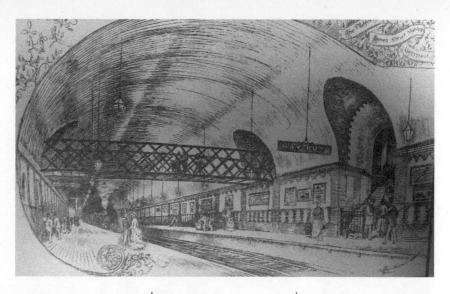

As the time approached when the work of constructing the tunnel would be completed, his Royal Highness graciously intimated his willingness to come to Liverpool to open the tunnel, at the same time informing the parties interested that he would be accompanied by her Royal Highness the Princess of Wales, the three young Princesses, and his two sons, Prince George of Wales and Prince Albert Victor. Hopes were entertained that the Right Hon. W. E. Gladstone, who from the first has evinced much interest in the progress of the tunnel, to which he on one occasion paid an unexpected visit, would also have taken part in the opening ceremony yesterday; but Mr. Gladstone's pressing Parliamentary duties made it impossible for him to be present.

Disappointment was also experienced in reference to the Princess of Wales, who, on account of indisposition, was prevented from coming to Liverpool with the Prince, her medical advisor imperatively vetoing the proposal that she should at this inclement season of the year undertake such a journey, whilst the non-attendance of her Royal Highness at the same time necessitated the absence of the three young Princesses. The Royal party, yesterday, was, however, very considerably augmented by the presence of a large number of distinguished guests from Eaton Hall, where his Royal Highness and the two young Princes were the guests of his grace the Duke of Westminster, having arrived at Eaton Hall early on Tuesday evening was of the most enthusias-

tic description, the streets of the ancient city being elaborately decorated and illuminated in honour of the visit.

In accordance with the programme prepared for yesterday's ceremony, and which, of course, had received the approval of his Royal Highness, the Royal party, some five and twenty in number, left Eaton Hall yesterday morning about eleven o'clock and drove to Chester Station, where a special train was in waiting to bring them to Birkenhead. Amid loud cheering the Royal train started at twenty minutes to twelve o'clock, the Central Station of the Mersey Railway being reached in half an hour from that time. Here a deputation from the loyal citizens of Birkenhead was in waiting to give their

Royal Highnesses a right loyal welcome on behalf of the "city of the future," now indissolubly linked by means of the tunnel railway with the second city in the kingdom. The deputation - which comprised many members of the Town Council - also came prepared with an address, and so did a deputation of the directors of the Mersey Railway Company, and both addresses having been duly read and responded to, his Royal Highness and friends passed on to the next station in Hamilton square, where more of the people of Birkenhead were in waiting to catch a glimpse of Royalty as the train passed through. The tunnel itself was next traversed by the Royal train, and considerably before the appointed time his Royal Highness emerged from the tunnel at James street Station by means of one of the hydraulic lifts, and in a sentence formally declared the tunnel to be duly open almost before the immense concourse of people in the neigh-bourhood of the station was aware that his Royal Highness had arrived.

The preparations made on this side of the river for the reception of his Royal Highness were of a most elaborate character. The route to be taken by the Royal party from James-street to the Town Hall - where a Corporation address was to be presented and the Prince and a large number of other guests entertained to a *déjûner* - elaborately decorated, whilst from every building in the neighbourhood there floated either a Royal Standard or a Union Jack. Dale-street and Water-street also showed a lavish display of flags and bunting, and in other parts of the city the tradespeople showed their loyalty in a similar manner, whilst many of the shops were closed in honour of the day. All the banks in the city were closed between the hours of half-past twelve and half-past two, and the parish church bells and the bells at the Municipal Offices rang out merry peals whilst the Royal visit lasted.

Unfortunately, the weather was not the most desirable for a visit from Royalty. The morning opened cold and foggy, and though the snow, which fell so plentifully on Tuesday morning had been pretty well cleared away from the streets there was a dampness under foot which was far from comfortable for those who took up positions along the line of route, or in the neighbourhood of the Town Hall or railway stations. In spite of the damp and the cold, however, the onlookers in James-street, who were present in their thousands, cheered his Royal Highness most lustily when they realised his presence at the station, and the cheering was renewed again and again as the Prince and young Princes drove with the Mayor to the Town Hall. The immense crowd assembled in front of the Town Hall and in Water-street and Dale-street caught up the enthusiasm, and amid further cheers his Royal Highness and the other members of the Eaton Hall party entered that building.

On 7 August 1889 Florence Maybrick was convicted of poisoning her husband with arsenic and sentenced to death at St George's Hall. The case was a huge cause célèbre all over the world and attracted strong public sympathy. Her sentence later commuted to life imprisonment but after fourteen years she was released. Florence lived out her final years in her home country of America and died a penniless recluse in 1941.

8th August 1889, Mrs Maybrick's Doom, Liverpool Echo

THE LAST SCENES OF THE GREAT TRIAL

The Death Sentence

There was electricity in the atmosphere yesterday, when Mrs. Maybrick made her appearance in the dock for the last time, and when it was known that that day would decide the question of her fate. The multitude who surrounded St. George's Hall was larger and more eager than ever, and hundreds of privileged persons swarmed round the corridors and were contented with the glimpses of the court they caught through the occasionally opened doors, while only the most fortunate of these were permitted to enter the court as room was made.

The jury retired to consider their verdict at eighteen minutes past three, the ushers being sworn to keep them in custody according to the usual form.

During the interval between the retirement of the jury and the return of the judge into court, which took place at ten minutes to four, there was a loud and universal buzz of conversation, followed when his lordship appeared by a dead silence. The early return of the judge was at once taken as a sign that the jury were coming, and it was thought that if they had made up their minds in so short a time there could have been but one result, and that a favourable one.

The jury returned at four minutes to four, and the whole of the persons in court rose and stood in silence. The silence and the tension of the moment was most impressive. After being asked by the Clerk of Arraigus whether they found the prisoner guilty or not guilty, the foreman of the jury pronounced the verdict in a low voice, "GUILTY."

After an instant's hush there was a loud murmur—half a groan and half an ejaculation of astonishment; but it was most decidedly expressed and felt throughout the court, and during the following few moments of the pronouncement of the dread sentence there were few who were not shaken with the pain and agitation of the terrible scene.

At the moment of the verdict, the prisoner—who had been looking up confidently towards the jury-box (though she might have guessed by the averted faces of the jurymen what was to happen)—dropped her head down on one hand, resting it almost on her knee, and sat in that attitude for about fifteen seconds and amid the profoundest silence. At this moment a second warder came up to and stood behind her in order to be ready in case of the prisoner requiring assistance. The prisoner was first asked if she had anything to say why sentence of death should not be passed upon her, and at this question she rose, and, looking boldly at the judge, said with emphasis, "I am *not* guilty." She continued in a very low voice, but

still maintaining her proud demeanour to the effect that though she was guilty so far as her connection with Brierley was concerned, she was innocent of the crime.

The judge then placed the black cap on his head, and pronounced in the usual way, and without any special indication of feeling, the sentence of death. As the words, "and be hanged by the neck until you be dead," were spoken, the prisoner trembled visibly; and when his lordship added the sentence, "May the Lord have mercy on your soul," she bowed her head in reverence and clasped her hands in front of her. The female warders stepped forward to support her on either side, and to lead her down the steps from the dock, but by a turn of the head she indicated that she did not require their assistance, and she then walked down the steps with great firmness.

At this juncture the jury were about to be discharged, and as they stood up loud hisses were heard through the court. When the verdict became known outside there were loud groans and hooting from a very large portion of an immense multitude that had assembled, and there were several scenes of a very excited character, almost every-one who came out of the building being subjected to unpleasant scrutiny and inquiry.

Everton Football Club moved to its new home at Goodison Park on 24 August 1892. It is one of the world's oldest purpose-built football stadiums.

25th August 1892, Liverpool Echo

THE EVERTON FOOTBALL CLUB
Opening Ceremony By Lord Kinnaird

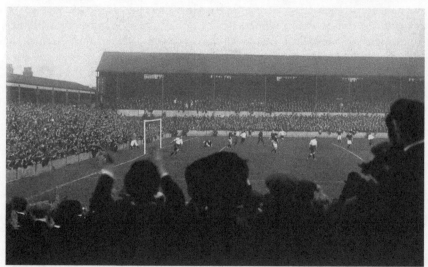

The Everton Football Club, which, it will be remembered, underwent a decisive change last winter, celebrated the opening of its newly-acquired ground at Goodison Park, Anfield, last evening. The club is lucky in having secured what is perhaps the finest ground in England, and the enterprise displayed in its acquirement will doubtless be fully repaid before the close of the coming season. The ground and stands have already been fully described in these columns, and when we reiterate that there is accommodation for 50,000 people, it will be readily understood what pains the executive have taken to secure adequate quarters for their patrons.

The committee of the club entertained to dinner at the Adelphi Hotel yesterday the principal officials of the various football associations, amongst whom were Lord Kinnaird, president of the Football Association; Mr. J. J. Bentley, chairman of the Football League; Mr. H. Lockett, secretary of the Football League; Mr R. P. Gregson, secretary of the Lancashire Association; Mr. R. E. Lythgoe, secretary of the Liverpool Association; Mr. M. Earlam, secretary of the Combination; Messrs. W. and J. Kelly, contractors for the stands &c.; Mr. James Prescott, architect; and Mr. M. Churchill,

secretary of the Liverpool Police Athletic Society; &c.

On the conclusion of dinner, Mr. Mahon, president of the Everton Football Club, who occupied the chair, proposed the health of the Queen, which being duly honoured, the chairman proposed the toast of "Association Football," coupled with the name of Lord Kinnaird.

Dr. Morley responded on behalf of the Association, and said that football had gone through a great number of changes during the last few years. He was glad to see that the old spirit of rowdyism was fast dying out, and that a true feeling of sportsmanship now actuated both players and spectators alike.

Mr. Bentley and Mr. Earlam having briefly replied on behalf of the League and Combination respectively.

Lord Kinnard proposed the toast of "Success to Everton." He did not want to make any invidious distinction, but he believed football to be as good a game as any, cricket not excepted. He was glad to hear Dr. Morley say that they had determined to maintain a sportsmanlike feeling in the game, and that anything like rowdyism was to be severely condemned. He trusted that the game would always

be second to none, and an honour to the country. With regard to betting, many people severely criticised the game on his head; but he was confident that where the community of any club were firmly resolved to discountenance this odious practice it might be effectually put down. He was a staunch advocate of clubs having a ground of their own – a freehold that would be not only an acquisition to themselves, but to generations to come (cheers).

The Chairman, in replying on behalf of the directors, said that they had secured a seven years' lease of the Goodison Park ground; but hoped, as soon as funds permitted, to purchase it outright (hear, hear).

The company then drowned the ground at Goodison Park, which was crowded with quite 10,000 spectators. Lord Kinnair having duly declared the ground opened, the band of the 3rd V.B.K.L.R struck up a lively-air, and a short programme of athletic sports, confined to the professional members of football clubs, was gone through. As darkness set in, the ground was illuminated with a grand display of fireworks, and the ceremony of opening the Everton Football Ground was most successfully concluded.

Liverpool's Overhead Railway was the world's first electric elevated railway and the first to use automatic signalling and electric colour light signals. It was also home to the first railway escalator. Known locally as the Dockers' Umbrella, it allowed for efficient travel between the working docks and warehouses which dominated the City's waterfront.

4th February 1893, Liverpool Echo

OPENING OF THE OVER-HEAD RAILWAY

Presentation To Lord Salisbury

Ceremony At The Bramley Moore Dock.

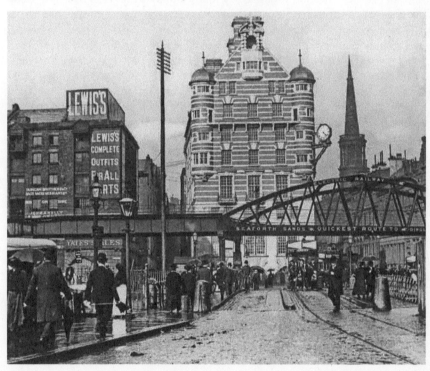

The Marquis of Salisbury opened to-day, amid many evidence of great public interest, the Liverpool Overhead Railway, just completed along the line of docks. This important undertaking, originally contemplated by the Dock Board, was, after having been for some years allowed to remain in abeyance, begun by the present company at the end of 1889. Since then it has been pushed rapidly forward, and in spite of grave engineering difficulties successfully completed without mishap. The engineers of the scheme are Sir Douglas Fox, M. Inst. C. E., and Mr. J. H. Greathead, M. Inst. C. E., and the acting engineers Messrs. Francis Fox, C. E., and G. B. Cottrell, and the fact

that the work had been carefully planned is shown by the rapidity and safety with which it has been carried out. The general contract was entrusted to Mr. J. W. Williams, who was represented in the works by Mr. F. Huddleston, M Inst. C. E., a gentleman to whom credit must be given for the design of the tilting and swing bridges, which are a special feature of the engineering displayed in construction. The total cost of the railway, including equipment, is about £510,000, or £85,000 per mile. There have been used in it construction about 25,000 tons of iron and steel.

The chief interest, however, of the railway centres in the generating station at Bramley-Moore Dock, where this morning Lord Salisbury, by starting the main electric current, formally declared the line open. The spacious station, formed out of twelve arches of the viaduct under the coal sidings of the Lancashire and Yorkshire Railway, contains four magnificent horizontal compound engines, each of 400 indicated horse power, driving Elwell Parker dynamos capable of sending along eight thick underground wires 2,000 horse-power of electricity. The current passes to a steel conductor placed on porcelain insulators between the rails on each line of the railway, and is transmitted to the motors on the trains by means of cast-iron "collectors." Only 5 per cent of the electricity is said to be lost in this process. Each train, lighted by electricity, is composed of two carriages with seats for fifty-six passengers, and has a motor at either end. The maximum speed is thirty-five miles an hour. The generating engines are by John Musgrove and Sons, of Bolton, and the six 30ft by 8ft. Lancashire boilers used for the generation of steam are also built by Musgroves. The newest mechanical improvements are used. In the length of the railway from the Alexandra to the Herculaneum Dock there are thirteen stations, and the line is supported upon channel iron columns 50 ft apart, with the exception of the crossings over swing bridges at the docks, where there are spans of 100ft. Over these the line is sustained by bowstrung girders. A remarkable feature of the railway is the fact that the flooring is constructed of an "arch plate" patented by Mr. G. A. Hobson M. Inst C. E. The plate was used on this railway for the first time, and is considered an important improvement. The carriages of the railway, light, elegant, and from a scientific point of view extremely interesting, have been built by Messrs. Brown, Marshall, and CO. of Birmingham. All have been fitted with compressed air brakes. The signal system of the railway is also worked by electricity, a new departure in railway management.

In 1809 William Gladstone was born at No. 62 Rodney Street and went onto serve as Prime Minister for a record-breaking four separate terms. He died on 19 May 1898 at his home of Hawarden Castle, Flintshire.

18th May 1898, Liverpool Echo

MR. GLADSTONE

The Dying Statesman's Last Moments. Calm And Peaceful Sleep. Mrs. Gladstone's Touching Devotion. This Morning's Bulletin.

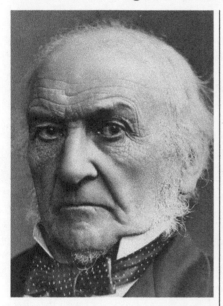

At a quarter to eight this morning the following bulletin was issued at Hawarden Castle:-

Mr. Gladstone remained in the same quiet and slightly improved state until 4.30 this morning, when the strength again diminished, the pulse became imperceptible, and it was thought he might soon pass away. He has again rallied, and he is now sleeping peacefully.

(Signed)

S. H. Habershon, M.D.
W.M M. Dobie, M.D.
Hubert E. J. Biss, M.B.
Hawarden.

The scene in the sick room.

Our Hawarden correspondent telegraphs:- The weather this morning in Hawarden is bright and balmy, and in striking contrast with the inclement elements yesterday. Our representative, on inquiry at the castle this morning, was informed that the members of the family maintained a vigil throughout the night in the sickroom. The three medical practitioners now at the castle examined the aged statesman at intervals, finding him mostly in a calm sleep, but about four o'clock it was discovered that his vitality had further decreased. All the members of the family were summoned to the room, as then end seemed to be at hand. They were kept in uncertainty for fully an hour, at the end of which the distinguished patient rallied and again fell into a calm sleep, and was still in peaceful slumber when the quarter to eight bulletin was issued. His condition is however critical and the end is expected at any moment. It is thought not unlikely that he will pass away whilst in a calm sleep.

Mrs. Gladstone's Touching Devotion.

Another special correspondent telegraphs:-

All through the night a weary vigil was maintained. The whole family were in and out of sickroom. Mrs. Gladstone remained throughout by the bedside of

her dying husband, whom she could not be induced to leave even for refreshment and a few minutes' rest. The scene at about four o'clock, when it was supposed that the last hour had come, was most painful and agitating, but again Mr. Gladstone showed his almost superhuman vitality, and fought death away. He then relapsed into sleep. It is believed, however, that his hours are not only numbered but very few.

The correspondent is in a position to state that in the opinion of the family, the right honourable gentleman will pass away about noon to-day. All Mrs. Gladstone's kith and kin give evidence in their appearance of the severe strain to which they are being subjected.

Will Never Speak Again.

As the early hours of morning drew in villagers collected around the Castle apparently with the object of ascertaining whether there was a prospect of any pronounced development. At three o'clock it was intimated that Dr. Habershon had retired to rest, and from the circumstances it was inferred that nothing in the nature of an immediate collapse was expected. The doctors think that Mr. Gladstone will never speak again. At the time

of telegraphing he was in a deep sleep. The family are in turn keeping watch at the bed-side, and this vigil will be maintained till the end comes.

Last Night's Reports

Commencing with a bad and restless night, Mr. Gladstone had had poor and broken sleep.

Later on, however, the condition of the right hon. gentlemen became more grave, and Mr. Henry Gladstone, who was away in London, and the Rev. Stephen Gladstone were at once summoned to the bedside of their aged father.

About half-past one Dr. Dobie, of Chester, arrived at the Castle, and at once repaired to the sick-room, where he found Mrs. Gladstone closely watching her suffering husband.

Mrs. Gladstone knows the worst, and is making a brave effort to bear up. The other members of the family are also in the sick chamber or near at hand. Mr. Gladstone lies with his back to the windows, and thus his face is slightly in the shade.

At eight o'clock in the evening, Mr. Gladstone was pronounced to be fairly easy, and obtaining slight rest.

The whole of the members of the family sat down together to dinner as usual.

The Hawarden Servants And The Patient. Touching Farewell.

A very affecting ceremony took place at the Castle while the family were at dinner. The whole of the servants were summoned into the sick room to take farewell of their respected and revered master. They found Mr. Gladstone lying on his right side in deep sleep, just as if, to use the words of one his faithful retainers, he was dead. Each servant in turn touched Mr. Gladstone's hand by way of final farewell, and then with tear-bedimmed eyes, turned and left the room.

Amongst others who have arrived are Miss Phillimore and Mrs. Wickham.

Interview With Dr. Dobie.

Dr. Dobie, on leaving the Castle, but with the intention of returning later last night, remarked in the course of an interview:-

"Mr. Gladstone is very much worse and the end is likely to come very quickly now. About an hour ago we gave him a little medicine, when he called out, 'No, no.' He had become very cold, but we got some hot water bottles, and we have made him warm now. I intend to come back again at ten o'clock, and remain the night at the Castle."

"Does he speak at all, doctor?"

"Very little; scarcely at all," replied Dr. Dobie. "Strange to say, he has taken to murmuring in French. When spoken to in English he sometimes replies with a word or two in that language, but at other times he seems to be trying to pray and in French for I have caught the words 'commencer' and 'prier.' He had very serious attacks of the heart, and there has been altogether a very rapid failure since I last saw him, and spoke of his life being probably prolonged for a fortnight."

"Was he conscious when you just left the Castle, doctor?" was the next question.

"No," replied Dr. Dobie; "he is practically unconscious - delirious. He has what we call the change stroke in his breathing, that is to say, he breathes heavily for a few minutes and then it is scarcely perceptible."

"Can you tell me anything as to the patient's appearance?" was the next question.

"He looks a wondering good colour," replied the doctor; "that was so when I left. Previously his hands had gone rather purplish, and there was a purplish tint about the mouth; but when I left just before leaving his hands and got a nice colour again."

"Do you think he is suffering at all!" was the next query.

"I think he has no pain now," replied the medical man. "I asked him if he had any pain but he did not answer."

Another correspondent at Hawarden telegraphs that Mr. Gladstone had a serious relapse yesterday forenoon and there was little hope that he would survive the night. It has been well understood in the family circle and in the medical profession that the malady from which Mr. Gladstone has been suffering for several months past must inevitably result in death within a period, the atmost limit of which was fixed at the end of June. The existence of the malady - a peculiar form of cancer - was first suspected during Mr. Gladstone's stay at Cannes, and the disease was actually diagnosed with certainty by the specialists who were called in while the patient was staying at Bournemouth that the fatal news was communicated to the right hon. gentlemen, and it was received with a fortitude which might have been expected of a man of Mr. Gladstone's exalted character. His sole request was that he might be permitted to die at Hawarden, and it was in consequence of this

wish that the memorable hurried departure was made from the pleasant watering place. Additional pathos, therefore, attaches to Mr. Gladstone pathetic farewell to Bournemouth, and to the blessing which he invoked upon its people, some of whom were in the mournful group which witnessed the departure of the illustrious sufferer. After his return home Mr. Gladstone seemed to derive temporary benefit from the change of air, and renewed association with familiar scenes. He was able to stroll about the grounds of the Castle on sunny days, and to converse with his friends and family with little restraint on the part of his medical advisors. This cheerful state of affairs, however, did not last long. The improvement proved to be delusive. The local malady made steady progress. The patient lost strength almost daily, and his ability to withstand the strain was not increased by the necessity for administering drugs to lessen the pain of the disease, which would otherwise have quickly become unbearable. From the beginning Mr. Gladstone's mental faculties have been absolutely unimpaired, and, as already explained, the resources of science have recently been successful in reducing the physical

pain to a minimum. At the beginning of this month Mr. Gladstone was given to understand that a fatal issue to his illness was then a question merely of weeks, and he decided the time had come to take farewell of his personal friends.

The country fell into national mourning upon the death of Queen Victoria on 22 January 1901. The Queen had visited Liverpool on numerous occasions and was held in high regard. She is proudly commemorated by the Victoria Monument in Derby Square.

22th January 1901, Liverpool Echo

DEATH OF THE QUEEN TELEGRAM FROM THE PRINCE OF WALES.

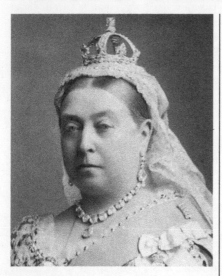

Osborne, 4 p.m. – Painful duty obliges me to inform you that the life of our beloved Queen is in the greatest danger.
(Signed) Albert Edward.

The Lord Mayor has sent the following reply to the Prince of Wales's message:
"I have received your Royal Highness's sad intimation with profound sorrow, which is shared by the citizens of London, who still pray that, under Divine providence, the irreparable loss to her Majesty's devoted family and loyal subjects throughout the empire may yet be averted. Will your Royal Highness be pleased to accept expressions of our deep sympathy?
"(Signed), FRANK GREEN,
Lord Mayor of London"

The following has been received by the Lord Mayor:–
Osborne, 6.45– My beloved Mother has just passed away, surrounded by her children and grandchildren.
ALBERT EDWARD.
Before The Death.
Last Bulletins.
The following has been posted at the Mansion House:–

The following bulletin was issued this afternoon:–
"Osborne, 4 p.m., January 22.–The Queen is slowly sinking.
(Signed)
"James Reid, M.D.
"R. DOUGLAS POWELL, M.D.
"THOS. BARLOW, M.D."

The following official bulletin, issued from Osborne House at noon, reached us at 1.15 p.m. :-

Osborne, Midday. - No change for the worse in the Queen's condition since this morning's bulletin.

Her Majesty has recognised several members of the Royal Family who are here.

The Queen is now sleeping.

(Signed)
JAMES REID.
R. DOUGLAS POWELL.
THOS. BARLOW.

The following official bulletin was issued this morning:-

Osborne, January 22 1901, 8 a.m. - The Queen this morning shows signs of diminishing strength, and her Majesty's condition again assumes a more serious aspect.

(Signed)
"JAMES REID, M.D.
"R. DOUGLAS POWELL, M.D.
"THOMAS BARLOW, M.D."

Unofficial Reports.
Royal Family Summoned To The Sick Room.
The Exchange Telegraph Cowes special correspondent wired from East Cowes at 10.15 a.m.:- The Rev. Clement Smith, rector of Whippingham, who was sent for has just arrived at Osborne House. The Bishop of Winchester is present, and the Royal Family have been summoned to the Queen's bedroom.

The Household and the Unfavourable Bulletin.
Statement By The Bishop Of Winchester.
Queen's Strength Gradually Ebbing.
A special correspondent at Cowes, wiring this afternoon, says: - There is the greatest grief among the household at the latest relapse in the Queen's coronation.

When her Majesty's private secretary learnt the contents of the bulletin he was very much distressed.

The two Indians, who are the personal attendants, were also moved to tears.

Shortly before twelve o'clock the Bishop of Winchester left the Castle I asked his Lordship if there was any change at the time he left the house. He replied, "No, nothing further than was contained in the last bulletin. Her Majesty's strength appears to be gradually ebbing."

A SUDDEN AND ALARMING CHANGING.
Cowes, 9 a.m. - The Central News correspondent telegraphs: - I regret to say the condition of her Majesty has taken a sudden and alarming change for the worse. The members of the family who slept out of the Castle have been summoned, and all are now assembled at Osborne. It is evident from the wording of the last bulletin that the immediate situation gives rise to the gravest apprehensions.

More Departures for Osborne.
The DUCHESS OF YORK AND Mr. BALFOUR LEAVE LONDON
The Duchess of York, attended by the Hon. Derek Keppel, Princes Arthur and Victor of Connaught; Princess Margaret, attended by Colonel Egerton and Mr. A. J. Balfour, left London by special train at 1.40 p.m. for Osborne. A large crowd witnessed the departure of the distinguished travellers.

The railway company had kept the special train in readiness all through the night, but they did not receive notice that it would be required until one o'clock to-day. Arrangements were immediately made, and a small group of people gathered in the precincts of the station. About 1.30 the younger members of the Royal party arrived at the station, and they were quickly followed by Mr. Balfour. At 1.35

the Duchess of York arrived, with her attendants. The crowd greeted the distinguished travellers by a general raising of hats.

The Duchess of York and Mr. Balfour arrived at East Cowes at six o'clock.

Prince Christian came up from Windsor at 1.10 this afternoon, and left Waterloo at 3.30 for Osborne, Colonel Egerton seeing him off.

Lord Clarendon arrived at Osborne shortly after three o'clock.

Britain celebrated as the coronation of King Edward VII took place on 9 August 1902. At the time of his ascension the King was already fifty-eight and reigned for only nine years. A striking equestrian monument to the King stands at the Pier Head.

9th August 1902, The Liverpool Football Echo

THE KING'S CORONATION
Day Proclaimed By Royal Salutes
Gay and Busy Scenes in London
Promise Of A Beautiful Day.

KING EDWARD'S HEALTH
His Majesty In Excellent Spirits

THE GATHERING AT THE ABBEY

NASTY ACCIDENT AT THE MALL.
FEATURES OF THE GREAT THRONG.

King's Nurses and African Heroes Cheered. Hearty Welcome For The Naval Brigade. Ireland's Sole Nationalist Representative.

At 4.36 this morning Royal salutes began to be fired from the Tower of London and Hyde Park, announcing that the Coronation celebration had commenced. The weather is fine.

It would be difficult (says the Exchange Telegraph Company) to tell at what precise time the earliest of the spectators began to take up their positions in the vicinity of Buckingham Palace, but there is little doubt that the long vigil which was kept during the night preceding the last

Coronation was repeated to-day. The pathetic circumstances which led to the postponement of to-day's ceremony from the date originally fixed were sufficient to account for the greatly increased interest which was manifested in to-day's proceedings. Scarcely more than six weeks have elapsed since the announcement was published from Buckingham Palace on the very eve of the Coronation that his Majesty was about to undergo a serious operation. Since then the Royal progress towards convalescence has been followed with anxiety, which was entirely dispelled on Wednesday, when his Majesty arrived in London from Cowes, and drove in an open carriage to Buckingham Palace. It was only natural, therefore that the King's subjects should have desired this opportunity of heartily welcoming the King after his remarkable recovery. As soon as it was dawn, and the first discharge of guns took place, people began to take up their positions; and as the morning wore on, and the early trains commenced to pour their living freights into the metropolis, the scene in neighbourhood of the Palace was one of utmost animation. It was early seen that the day would be beautifully fine, and this naturally had a happy effect on the spirits of the crowd. By eight o'clock most of the route was occupied, and the line of sightseers was everywhere becoming more dense. The streets became packed with private carriages and State coaches, while the troops (mounted and foot) marching with bands playing to and colour. Everywhere naval, military, take up their positions, added to the life, and State uniforms were prominent, and, with these and the tasteful and elaborate decorations, the scene suddenly became one of extreme gaiety and brilliance.

Outside The Abbey.

Outside the Abbey the scene was brilliant and animated one. Guards held all the thoroughfares leading to the Abbey, and no civilians were allowed within the immediate approaches. At the door of the Abbey beefeaters were stationed, and peers and Abbey guests arrived in carriages in constant succession. The Earl Marshal stood at the door to the annexe of the Abbey and received the peers. General Trotter, commanding the Home District, and other officers passed along the route at 8.30 in a motorcar supervising the military arrangements.

Buckingham Palace at 9.30.

At 9.30 the scene in the vicinity of Buckingham Palace was one of the greatest animation. The roof of the Palace and all the surrounding buildings are crowded with spectators and large numbers of people are taking up their positions in the places still vacant in the Mall and elsewhere.

Every arrangement has been made for treating cases of accident. Owing to the coolness of the day it does not appear probable heat prostration cases with be numerous.

Scene In The Abbey.

From the opening of the Abbey doors at seven o'clock and nine o'clock the seats reserved for the peers and peeresses, the members of the House of Commons and their lady friends were but sparsely tenanted. Three or four peeresses were in their slotted places a few minutes after seven but they remained the only spectators of their rank for more than an hour. Shortly before nine o'clock the scene became more animated, peers and peeresses arriving in quick succession, while members of the House and their fair friends were strongly represented. Quite an astonishing number of his Majesty's faithful Commons wore the

uniform of deputy lieutenant and of military men. There was also a strong must of Guardsmen, Riflemen, Dragoons and Yeomanry – all were represented. Conspicuous is the solitary representative of the Irish Nationalist Party was Dr. Thomson.

Guard Of Honour At The Palace.

The guard of honour at the Royal residence consisted of a Naval Brigade, the Brigade of Guards, and the 2nd Battalion the King's Liverpool Regiment. Between nine and ten o'clock there was a constant stream of arrivals of Royal visitors at the Palace.

Both Routes Well Crowded By 10 a.m.

By ten o'clock every point on the route of both processions was filled, and the crowd in places was immense. Still, however, there was a continual stream of pedestrians pouring in from all directions. At ten o'clock all the barriers in the streets leading to the Abbey were closed, and consequently several peers. Including Lord Bosebery and Lord Balfour, and a number of peeresses had to alight from their carriages outside the barriers, and walk to the Abbey.

Inside The Abbey.

The bishops were all in their places by half-past nine, and the Colonial Premiers, conspicuous among whom were Sir Wilfrid Laurier, Sir Edmund Barton, and Mr. Seddon, were among the first comers, the indefatigable Prime Minister of New Zealand being absolutely the first comer. At half-past nine there were very few places vacant in the Commons gallery, but many seats remained unoccupied by peers and peeresses who a quarter of an hour later filed in rapidly. The Abbey choir boys have sweet voices, and the loud hum of conversation was appreciably hushed when shortly before ten the choir sang with beautiful express the anthem for the day "Rejoice to-day with one accord." The scene was now impressive and brilliant in the extreme, the bright uniforms of the men and the stately toilettes of the women wonderfully relieving the sombre beauty of the Abbey. The reconsecration of the regalia was solemnly performed at ten o'clock, the choir singing, "O God our help in ages past."

Crowd Not So Large As Expected.

The Central News says: – The dawn broke with a slight haze hovering over the Metropolis, and with a taste of autumn pungency in the air. By six o'clock the sun had dispersed the mist, and half an hour later was shining with a brilliancy well becoming a day of such historic interests to the Empire. The prospects for the day were so far excellent, and provided the promise holds good, his Majesty will have one very essential element of complete success assured to him.

The crowd, however, in the early morning was not nearly so large as was expected. True there were many enthusiasts who with campstools and ample supplies of provisions, had taken up their positions soon after the midnight hour had chimed, but these secured nothing by their night's vigil. The same positions could easily have been secured at six o'clock this morning. At that hour troops were quickly marching to their allotted stations, and police, at three paces interval, lined the well-gravelled route from Buckingham Palace to the Abbey. But in the Mall itself at half-past six there were certainly more police than people, and the same might be said for Pall Mall. The first sign of what might be called a crowd was at Charing Cross, whilst in Parliament-street and the lower portions near the Abbey the people were standing six deep.

Probably the various police warnings and

dismal prophesies of fearful rushing had deterred tens of thousands from gathering to cheer his Majesty on his crowning event of his life. As tram after tram from the suburbs discharged living freight at various points in the vicinity of the route it seemed absolutely certain that every inch of available space would be occupied long before the Royal procession emerged from the Palace. It was a noteworthy feature amongst these early arrivals that all seemed prosperous citizens. It was essentially a well-dressed and decorous crowd of whose loyal devotion any monarch in the world might well be proud. There was little enthusiasm amongst them yet, but they all seemed bright and happy and ready to let themselves go when the crucial moment arrived.

The Decorations.

The decorations have been very carefully preserved bunting has been fixed this morning, making the colouring on the route plentiful as well as pretty, but naturally the display is not nearly so lavish as the exquisite show prepared for the Coronation in June, a fixture which was so tragically broken.

In the suburbs, too, flags are fluttering in all directions, but here again the great holiday season drawing such vast numbers from the metropolis in August tells against combined efforts for a general display.

The suburban decorations to-day are not to be compared with the pretty designs of two months ago.

The King In The Best Of Health.

At Buckingham Palace everything promises well for the auspicious day.

The king is reported in the best of health and spirits.

A high police official reports that "nothing has occurred to disturb the harmony of the arrangements up to this hour, and everything indicates a highly successful day in the history of London demonstrations."

Abbey Doors Opened.

At seven o'clock the doors of the Abbey were thrown open, but the early arrivals were comparatively few, and only a small number of those having stand privileges had taken their seats by that hour.

Palace Yard, Westminster, 8.15 a.m. - The scene in the neighbourhood of the House of Commons is rapidly becoming lively. Crowds are now pouring into the stands and watching with the greatest interest the arrival of those privileged persons possessing tickets for the Abbey. The historic building is rapidly filling. The ceaseless rattling of carriages at various points and the ever-increasing hum of hurrying crowds taking their seats along the line is in marked contrast to the usual quietness of the city of Westminster at this early hour. Bands are already in position and are discoursing sweet music, much to the enjoyment of the early comers. Joy bells, too, are pealing, and the spectacle already promises to be one of his greatest splendour. The sun, which had been shining so brilliantly earlier, has now become obscured by dull clouds. Nevertheless the weather indications are still promising.

A Stately Picture.

Parliament-street itself now offers a stately picture, the widening thoroughfare enabling those at Westminster to obtain a view of the picturesque and beautiful outlines of the Canadian Arch, beyond which Nelson on his column at Trafalgar-square stands out in solitary loneliness.

The bannerettes and venetian masts on either side of the thoroughfare add to the general beauty, whilst buildings on each side seem now to be teeming with life. As the carriages drove up to the Abbey the gorgeous apparel of many of the occupants

elicited expressions of loud approval from the good humoured and keenly appreciative crowd, which momentarily increased in dimension.

The Busy Motor.

A mighty cheer went up from the assembled thousands as the men of the Naval Brigade, who are to line a part of the route, went by as a swinging pace to the strains of their own band. One feature unique in the history of Coronations is the number of motor-cars which have been requisitioned to convey notabilities to the Abbey. The arrivals have now become so numerous that one wonders how even the Abbey can contain the number, and still the line of carriages coming up appears to be endless.

South African Heroes.

The Abbey is now (9.30) nearly full, yet carriages continue to arrive laden with ladies in the gayest of plumage and officers in the brightest of uniforms. Some of the South African heroes have been recognised by the crowd and heartily cheered.

The Scene In The Mall.

Buckingham Palace, 8.45 a.m. – It is only during the last hour that the Mall has become all animated, but now people are pouring in in large numbers, and taking their stand in this picturesque avenue. The most striking feature so far has been the numbers of infantry, Yeomanry, and Volunteers who have been marching through the park to their allotted places. The Egyptians aroused much curiosity. A troop of Indian Lancers rattling down Constitution-hill were greeted with a cheer. Then word went forth that no more carriages were to be allowed on the route, and General Sir Henry Trotter, in his motor-car, had the entire road-way to himself. With him rode the Duke of Connaught, whom the crowd recognised and cheered hastily, everyone joining in. Indeed, there is no room in to-days crowd for anyone who is not enthusiastically loyal. Sir Henry is flashing over the route like a meteor.

Thousands of eyes have been kept fixed upon Buckingham Palace now for hours, hoping to see some members of the Royal family, but up to this hour their persistency has not been rewarded.

An Alarming Accident.

What might have been rather serious accident has occurred near the Duke of York Steps, in the Mall. Lord Edward Pelham Clinton was driving to the Abbey in a closed Royal carriage when it collided with another Royal carriage going at high speed in the opposite direction. The collision was not very serious but the horses in Lord Edward's carriage were frightened and kicked over the graces, falling on the ground. The police promptly helped Lord Edward out of the carriage, and after some difficulty, extricated the horses.

The famous illusionist, magician and escapologist Harry Houdini (AKA Erik Weisz) made the papers during a visit to Liverpool in February 1904 after a particularly eventful stopover at the Cheapside Bridewell.

2nd February 1904

"PRISON-BREAKER" AT THE LIVERPOOL BRIDEWELL

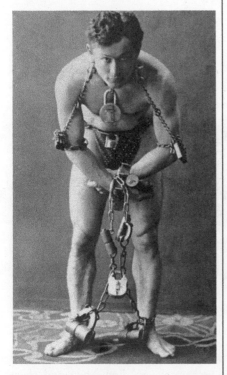

No Cell Can Hold Him

Mr. Harry Houdini, "the handcuff king and prison breaker," who is this week giving exhibitions of his extraordinary powers at the Empire Theatre. Lime-street, gave a private demonstration to-day at the Main Bridewell in Cheapside, before the Head Constable and police officials. His success astonished all, and he was congratulated on his ability to defy the ordinary "rules and regulations" of the bridewell, which hitherto had been found sufficient to keep in durance all the prisoners who have been "guests" of the State within the bridewell.

The ordeal through which Houdini was put to-day and which he emerged triumphantly, is fully explained in the following statement, signed by Mr. Dunning, Head Constable.

Central Police Office, Dale-street,
2nd February, 1904

I certify that to-day Mr. Harry Houdini showed his abilities in releasing himself from restraint. He had three pairs of handcuffs, one a very close-fitting pair, round his wrists, and was placed in a nude state in a cell which had been previously searched. Within six minutes he was free from the handcuffs, had opened the cell door, and had opened the doors of all the other cells in the corridor, had changed a prisoner from one cell to another, and had so securely locked him in that he had to be asked to unlock the door. – Signed

Leonard Dunning, Head Constable

The beginnings of one of Liverpool's most famous structures, the Anglican Cathedral, took shape in the summer of 1904. This mammoth building was designed by the eminent architect Giles Gilbert Scott and at 189m, it is the longest cathedral in the world. It also houses the world's highest and heaviest ringing peal of bells.

19th July 1904, Liverpool Echo

LIVERPOOL'S NEW CATHEDRAL.

This Afternoon's Function.

The Foundation Stone "Well And Truly Laid."

King's Reply To The Cathedral Address.

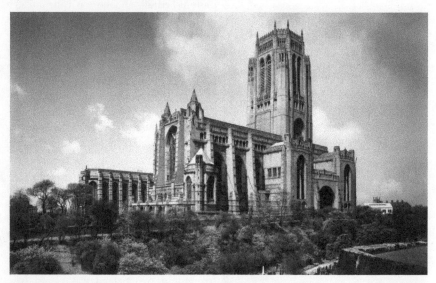

The Cathedral Site.

A guard of honour of the 2nd Lancashire Royal Artillery with three officers and 100 rank and file, with band, under the command of Captain and Hon, Major Osborne, were stationed at the Cathedral site. Children from the Liverpool Reformatory Schools were placed outside the railings around St. James's Cemetery, facing St. James's-road North. Immediately before the grand stand was reached children representing the Sunday schools in the city and Church Lads' Brigade, the Boys' Brigade, and the Jewish Lads' Brigade, were massed on special reserve stands on either side of the drive.

The grand stand was a glorious and impressive spectacle. He was a huge amphitheatre every tier of which was lined with distinguished people of the diocese, bishops and clergy, and many visitors,

numbering, all told, close upon 7,000. In the centre of the stand, as if wedged between the north and south portions, was the surpliced choir, 1,000 strong, and the Grenadiers' Band, as the musical accompaniment. Both choir and clergy (the latter numbered about four hundred) robed in the Liverpool Institute, and reached the Cathedral site in procession shortly after three o'clock. On a specially raised platform around the huge foundation-stone was the Royal dais, which faced the grand stand.

The foundation-stone weighed 5½ tons, and measured 7ft. 10½in. in length, 4ft. 6in in width and 2ft. 4in. in depth. The huge block is of red (Runcorn) sandstone, and on the front had been inscribed the words, "To the glory of God this foundation-stone was laid by King Edward VII. on the 19th day of July,1904," while on

the other side had been inscribed the text "Other foundation can no-man lay than that which is laid, which is Jesus Christ."

Laying The Stone.

On the arrival of their Majesties at the Royal dais, which had been erected upon the site, they were received by the Lord Bishop and Sir William Forwood, chairman of the Cathedral Committee. Upon the King and Queen taking their places the first verse of "God Save the King" was sung, after which the following gentlemen were presented: –

The architects (Mr. G. F. Bodley, R.A. and Mr. G. Gilbert Scot), the chairman of sub-committees (Mr. Robert Gladstone, Arch-deacon Madden, and Mr. Arthur Earle), and the treasurers (the Hon. Arthur Stanlet and Mr. F. M. Radcliffe.

Presentation Of An Address.

The Earl of Derby, president of the Cathedral Committee, then asked his Majesty to receive the address of the committee to his Majesty upon the occasion of the laying of the foundation-stone.

His Majesty having signified his pleasure the chairman of the committee (Sir William Forwood) read the address as follows: –

May it please your Majesty – The diocese of Liverpool was created in 1880. It comprises one of the most populous districts of Lancashire, including the city and port of Liverpool and the towns of Bootle, Ormskirk. St. Helens, Southport, Warrington, Widnes, and Wigan, and no less than a million and a quarter of people.

But this great diocese has never possessed a suitable Cathedral Church. Other and greater spiritual needs claimed to be first met, and absorbed, for nearly a quarter of a century the attention of the Church. Yet the vision of a Cathedral was never lost. It grew in strength and loftiness through years of waiting. Most looked for a stately building worthy of this great community with its stores of wealth, its worldwide connections, its untiring industrial activities, and its manifold interests, which should be reared by all and for all, and which should be handed down to those yet unborn as a witness for God, and as a centre of spiritual life and work and worship.

This hope is now on the eve of fulfilment, and it is with deepest sense of thankfulness to Almighty God that we have ventured to approach your Majesty, and our gracious Queen to further our undertaking, and most respectfully to ask your Majesty to be pleased to lay the foundation-stone of this the Cathedral Church of Christ in Liverpool, humbly praying that God may grant your Majesty and the Queen long and happy lives, and that He may abundantly bless this His work.

To this address were appended the signatures of Lord Derby (president of the Cathedral Committee), the Lord Bishop, Sir William Forwood (chairman of the Executive Committee), Mr. Robert Gladstone (chairman of the Building Committee) the Hon. Arthur Stanley and Mr F. M. Radcliffe then, treasurers), Mr. R. A. Hampson, Mr. Arthur Earle, Carlon Penryn, and Canon Willisk (hon. aecs.).

St Johns Gardens was once the site of a small Georgian church and graveyard, but in 1904 the site was redeveloped as an ornamental and memorial garden to provide a more pleasing setting for the neighbouring St George's Hall. The largest monument within the gardens is dedicated to The Kings Liverpool Regiment, one of the oldest infantry regiments of the British Army. This was unveiled on 9 September 1905.

9th September 1905, Liverpool Echo

THE UNVEILING OF THE WAR MEMORIAL

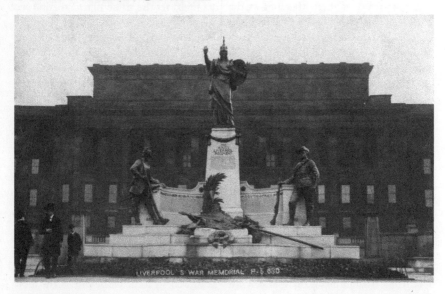

The monument in St. John's Gardens of which the foregoing is a photogravure is a worthy tribute to the many warlike achievements of the King's Liverpool Regiment, whose proud motto, rendered into English, is "Difficulties do not frighten us!" Its history, extending over 200 years, shows the regiment to have behaved with creditable bravery in Egypt, under Marlborough, and on the battlefields of Blenheim, Ramilles, Canada, Martinique, Niagara, Delhi, and Lucenow, &c. Their bravery in more recent campaigns is still fresh in the memory of the nation.

Sir George White In Liverpool.

Field-Marshal Sir George White together with Miss White, arrived in Liverpool yesterday, crossing over from Belfast, during the night. The steamer went direct to Prince's Dock, and Sir George, with Mr. White walked along the stage to the Woodside boat. At the other side of the river Sir George was met by Sir William Forwood and party. None of the general public were present, and only a few of the bystanders recognised the gallant defender of Ladysmith. During the afternoon the distinguished visitors

went for a 'motor-drive' in the surrounding country when Sir George expressed himself as charmed with the scenery. He appeared to be in excellent health. The object of Sir George White's visit is to unveil to-day the monument erected in St. John's Gardens to the memory of the fallen heroes of the Liverpool Regiment. It is stated that Lady White will be unable to come to Liverpool to-day.

Programme Of Arrangements

In yesterday's issue was published the full programme of to-day's proceedings as then arranged.

According to additional information since communicated, the Major of Birkenhead will be on the Woodside Landing-stage to meet Sir George White at 12.15, and after luncheon in the Town Hall special electric cars, starting at 2.45, will convey the Lord Mayor's guests to St. John's Gardens by the route described yesterday. The guards of honour originally arranged for in connection with Sir George White's departure for Ireland are being omitted.

The sad case of Madge Kirkby made headlines in 1908 after going missing from her home at No. 55 Romily Street, Kensington. Her badly decomposed body was discovered in a sack several months later. She had been raped and strangled, but her killer was never found.

9th January 1908

THE MISSING LIVERPOOL GIRL

Still No Clue

The police are still continuing their search for the missing Liverpool child, Margaret T. Kirby, seven years of age, who disappeared on Monday afternoon, when she was last seen in company of a strange man. So far the search has proved in vain. The description of the missing girl states that she has dark brown hair, blue eyes, a prominent nose, and a fresh complexion, and when she was last seen was dressed in a black skirt, worn at the sleeves, a blue pinafore, a black velvet bonnet with black strings, black stockings, and laced up boots.

It is only fair to the police to indicate the vast amount of work they have gone through in trying to trace the missing child. Between the time of her disappearance and last evening every unoccupied house not only in the immediate district where she was last seen, but throughout the whole of Liverpool, has been thoroughly searched by the regular police in uniform, some of whom have also made a careful examination of every spot which could possibly have been used for secreting a body. At the same time, no fewer than ten detectives, and these assisted by plainclothes officers, have been scouring the city in every direction, and making unoccupied houses regarding which any suspicion might possibly arise the scene of their earnest investigations. In doing this duty many of the police got so begrimed that some of the public, ascribing it to work in fire-extinguishing, asked them where the fire had taken place. At first, in looking at the matter, from various points of view, it was thought probable that the removal of the child might have been carried out by some sympathetic friend of the girl's deceased mother; but it appears that so far as can be ascertained, investigation in this direction has also proved abortive, and the police authorities seem to be at their wits' end in the case. Persistent rumours were afloat this morning that the missing little girl has been found, some

stories say alive. Inquiry at the Dale-street, Detective Office, however shows that no trace whatever of the child has yet been discovered.

The early twentieth century saw the Suffrage Movement grow in force. It members demanded votes for women and activists went to great and often illegal lengths to get their voices heard. A visit to the city by Prime Minister Herbert Asquith caused quite a sensation on 21 December 1909.

21st December 1909, Liverpool Echo

SUFFRAGISTS ARRESTED, DISGUISED AS ORANGE SELLERS

Scenes In Dale-Street

Armed With Catapult AND IRON MISSILES

Bottle Thrown At Mr. Asquith's Car

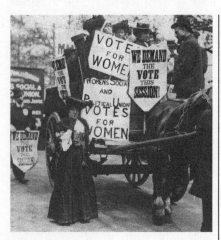

The Prime Minister reached the Reform Club at a minute past one o'clock. He arrived in company with Sir Archibald Willamson in the latter's motor-car.

For almost an hour prior to his arrival the police, under the direction of the Head Constable (Mr Dunning), the assistant Head Constable (Mr. Caldwell), Chief-inspector Smith, Chief-inspector Duckworth, and other officers, had been on duty outside the building, and kept wayfarers from loitering in too close proximity to the club portals it was evident that the suffragists were determined, if possible, to create a scene. Close upon a dozen of them were in the vicinity, but the police kept them under close observation, and as they walked up and down in couples in front of the club, each couple was followed at close range by a couple of detective officers. In this way they were kept continually on the move, and any concerted action on a large scale was effectually prevented. When the Prime Minister arrived outside the club the police promptly made a three-sided cordon across Dale-street. Nevertheless, the suffragists asserted themselves. Several of them made frantic efforts to break through the cordon, and a number of them shrieked, "Down with Asquith!" and "Votes for Women!" Mr. Asquith, however, stepped calmly out of the moto-car, and through the doorway of the club. For a few moments he tranquilly surveyed the scene, then smiling to Sir Archibald Williamson stepped into the vestibule, where he shook hands cordially with Mr. James Moon (chairman of the club).

The police arrested two women who were dressed as orange women, with aprons, shawls, and old hats complete, and who carried baskets of oranges. They were for some time suspected as masquerading suffragists and were closely shadowed by the police. When Mr. Asquith made his appearance their behaviour was considered by the police to be sufficiently disorderly to justify their taking the strange couple into custody and conveying them to the main bridewell.

Ginger Beer Bottle Used As A Missile.

Just as Sir Archibald Williamson's motor-car was moving away from the entrance to the Reform Club, after the Prime Minister had gone in a suffragette, who was dressed up as a basket woman, suddenly raised her right arm and deliberately threw something with great violence at the body of the motor-car. The missile, which turned out to be an empty ginger-beer bottle, went through the open window of the car, and landed on the cushions without doing any damage worth speaking about. If there had been anyone in the motor-car at the time, the consequences would undoubtedly have been very serious. The suffragette was immediately arrested, as was another suffragist, who was taken in charge just as she was in the act of following the tactics of her companion.

They were both taken to the Main Bridgewell, where they were booked as Selina Martin and Leslie Hall. They each gave addresses in London.

Police-Court Proceedings.

The two women, who are named Selina Martin and Leslie Hall, were later on brought up at the police court, before Mr. Little, the stipendiary magistrate, charged with behaviour likely to cause a breach of the peace.

Prisoners were remanded for inquiries for seven days.

There was found in the possession of one of the women arrested in connection with the motor incident, quite a small collection of dangerous looking objects.

Mr. Duder who prosecuted said, "These two women, your worship, are suffragists, and were arrested at five minutes past two to-day for disorderly conduct outside the Reform Club. Mr. Asquith had just left the motor-car belonging to Sir Archibald Williamson, which was being driven away, when the prisoner Martin threw a ginger-beer bottle so that it went through the window of the motor-car. The other woman was seen to put her hand inside her clothing, and it was afterwards found that she had a catapult and two pieces of iron on her. They were disguised as orange-sellers at the time.

Police Evidence.

Detective Barnett said that at five minutes past one he was outside the Reform Club. When the motor-car came along the two women rushed forward. They were selling oranges.

In answer to the stipendiary as to whether they had anything to say to the charge, both prisoners said, "No, thank you."

The Stipendiary asked the witness whether there was anyone sitting in the motor-car when the bottle was thrown. Witness replied that there was not.

Then you say it was thrown simply to break the glass?-That is so.

Was there anyone near that it might have hit? - Yes; about half a dozen gentlemen between the women and the motor-car.

Then it passed over their heads into the motor-car without breaking the glass? - That is so.

Did you see the prisoner Hall doing anything? - No with the exception of her raising her hands.

Mr. Duder remarked that the bottle went very close to the chauffer.

The Bottle-Throwing

Detective Kinley said he saw the prisoner Martin take the bottle (produced) from underneath her shawl and throw it at the motor-car just as it was driving away. He found the bottle lying at the bottom of the vehicle amongst the rugs.

Martin. – You said that when I threw the bottle there were half a dozen gentlemen in front. Do you say the bottle struck anyone?

Witness– No; it went over their heads.

Were those half-dozen gentlemen detectives? – No.

Detective-sergeant Leach said he was with the last two witnesses, and had the prisoners under observation for twenty minutes. He saw Martin throw a bottle from behind a number of people. The bottle went through the open window into the car. The other prisoner shouted, "Go on; that's it."

The wardress, who was present when the prisoners were searched, spoke to

Finding The Catapult

And pieces of iron on Martin.

Hall said: It was I who had the catapult and pieces of iron.

When asked if they had anything to say, Martin declared that she thought the case ought to be remanded until to-morrow to give them opportunity of preparing their defence.

Hall. – I say the same thing.

The Stipendiary said he would like to know something about these women, and it would be better if there was a remand for six days for inquiries to be made about them. They were accordingly remanded.

Applications for bail were afterwards made by the prisoners and refused.

The Liver Building is arguably the most recognisable construction in the whole of Merseyside. It had been the tallest building in Europe and was one of the first to be constructed of reinforced concrete. It was designed by the Wirral-born architect Walter Aubrey Thomas and opened on 19 July 1911 as the headquarters of the Royal Liver Group.

19th July 1911, Liverpool Echo

LIVER SKYSCRAPER
Inspection By Delegates

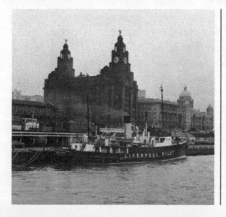

By means of a tour from basement to roof leads, the 270 delegates of the Royal Liver Friendly Society, who are holding a special meeting this week in Liverpool, gained a good idea yesterday of the new chief offices and the already famous electrical dock in the Pierhead "skyscraper." The fact that the 270 were conveyed from the ground floor to the ninth storey in three lifts, each carrying ten or twelve persons at a journey, within ten minutes, denoted the rapidity with which the ascent and descent can be accomplished. In all, there

are fifteen passenger lifts, each arranged to load up to 1,880 lbs. The speed ranges from 300 feet to 400 feet per minute. The automatic interlocking and speed governing arrangements having been demonstrated, the visitors observed the fine panorama on the river and on its Lancashire and Cheshire banks, the Mauretania, the Cymrie, and the Lanfranc being pointed out at moorings, while the Cathedral, works, Everton Church, Mossley-hill Church, St. George's Hall, the Tobacco Warehouse, the New Brighton Tower and fort, Port Sunlight, and many other features on either side were each indicated to strangers. The working of the clock was shown, and some expressed surprise that it neither strikes nor chimes.

In order to give succinctly the size and details of the building (which has been erected on the Hegnebique principle, from the designs of Mr. W. Aubrey Thomas) the party were informed that it occupies a site measuring about an acre and a quarter. The dimensions are 301 feet long by 177 feet wide. Up to the main roof the height is slightly over 170 feet. The domes of the two clock towers contains six storeys, making seventeen storeys altogether. The floor area is 40,000 square yards. The total weight of the building is 80,000 tons, there having been used in addition to 25,000 tons of granite. 30,000 tons of granite chippings and sand, 5,000 tons of cement, and for the "frame," 3,000 tons

of steel. The pipes for heating, if placed end to end, would reach fifty miles, while the seventy tons if lead lavatory pipes would extend over four miles. There are in the building 6,000 steel window casements and 60,000 square feet of quarter-inch plate glass. The electric cables are twenty-five miles in length and carried in eight miles of conduits. Each of the four clock chain measures 25 feet wide in diameter and is raised 230 feet from the ground. The hands are of hollow copper the mute hand being 14 feet long, and nearly 3 foot wide at the widest part.

Only once in thirty years, it may be here repeated, has the clock to be wound, and it works on principle known as the "waiting train."

In August 1911 Liverpool was crippled when workers went on strike over conditions following similar action in other ports. Liverpool saw an estimated 250,000 labourers down tools and the protests took an ugly turn when rioting broke out in the streets. The Government ordered troops to quell the disorder and even stationed a gunboat on the river Mersey.

10th August 1911, Liverpool Echo

THE RAILWAY WAR

More Wild Scenes in Liverpool. Riotous Mob Stone The Police.

Exciting Incidents At The Stations. Food Still Held Up.

The Liverpool railway war was continued today with undiminished vigour,

and again a number of turbulent scenes were witnessed. One of the most

exciting occurences was at Lime-street, where the mob strongly resented the

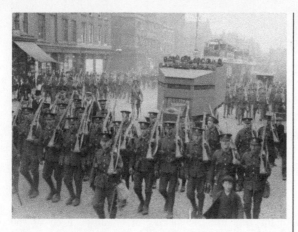

arrival of the police from Birmingham and Leeds, and greeted them in a very hostile manner.

In addition to the police reinforcements, a detachment of military has been drafted to Seaforth Barracks.

The position of affairs up to this afternoon is shown from the reports given below, and later details of the strike will be found on Page 8.

Excitement at Lime-Street
Police Arrive From Leeds and Birmingham.
Hostile Reception
Stones & Glass Thrown

There were riotous scenes in Lime-street this morning, although the inside of the railway station was quite quiet. From an early hour crowds began to assemble on the plateau of St. George's Hall, but they did not attempt to interfere with the transit of milk and other perishable goods.

Shortly before ten o'clock a detachment, 100 strong, of police arrived from Leeds and proceeded quietly to Hatton-garden. As the morning advanced the crowds in the neighbourhood increased.

A little before eleven o'clock 103 policeman arrived from Birmingham. They lined up four deep, and marched out of the main entrance of the station. A change apparently had come over the attitude of the crowd, for they gave the Birmingham force a most hostile reception.

Beginning by booing the constabulary, they commenced to throw stones, pieces of brick, and rotten fruit. Several of the police were struck, and one dastardly member of the crowd hurled a piece of glass, which struck a constable on the helmet. In spite of the crowd's demeanour the police marched steadily towards

the headquarters, followed by a jeering rabble.

Mob Rescue
A Prisoner

It appeared that during the events the police arrested a man in Manchester-street. The crowd turned upon the police-constable who had effected the arrest, and they succeeded in rescuing the man, but not before they had smashed a window in the shop of the Reliance Engineering Company, in whose doorway the police-man had taken refuge.

Baton Charge
Exciting Scene at Central Station.

A large crowd of strikers congregated at the Central Station this morning for the purpose of preventing the delivery of food-stuffs.

The police charged the strikers with baton drawn.

It is stated that one man was arrested.

Charges of Mounted Police

About a dozen vehicles, containing perishable foods have been convoyed from the Central Station by mounted police and police on foot. The mounted men had first to clear away the hostile crowd of strikers and other by making a baton charge, before which the mob, as many as could be described, scattered wildly.

The magnificent *Titanic* struck an iceberg in the middle of the Atlantic on the freezing night of 14 April 1912 resulting in 1512 tragic deaths. The ship was part of the White Star Line whose headquarters was at Liverpool's Albion House, James Street.

16th April 1912, Liverpool Echo

TITANIC SUNK. TERRIBLE DISASTER IN THE ATLANTIC.

FOUNDERS IN FOUR HOURS.

APPALLING LOSS OF LIFE.

LISTS OF THE SAVED.

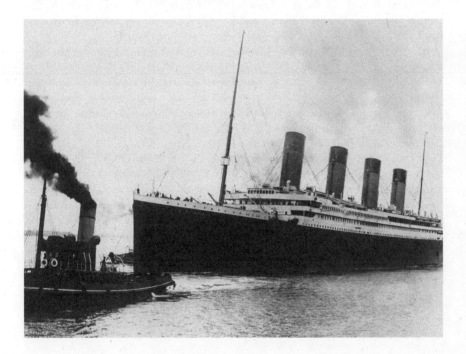

The Titanic the world's greatest liner has met with disaster on her maiden voyage to New York. Late on Sunday night she collided with an iceberg in 41.46 north latitude, 50.14 west longitude. She was badly holed, and, sank four hours later with nearly 1,700 of those on board.

Wireless calls for help were sent out by the Titanic immediately after the disaster, and were received by the Cunarder Carpathia, which left New York on Thursday for the Mediterranean and was in the vicinity at the time of the collision, by the Allan liner Virginian, and other

liners within a radius of a few hundred miles.

The Carpathia was, apparently, first on the scene, and picked up twenty boatloads of the mammoth liner's passengers and crew, numbering 675 in all. The Titanic carried altogether some 2,359 souls of whom over 1,400 were passengers.

TERRIBLE LOSS OF LIFE
Captain Among The Missing.
(Latest Cablegrams.)

The following special cablegrams were received, this morning, giving details of the awful mid-Atlantic catastrophe:-

Halifax (N.S), Tuesday - It is estimated here that 1,500 persons have perished in the Titanic disaster. As far as is known there is no trace of Colonel John Jacob Astor, Mr. Charles H. Hays (the president of the Grand Trunk Railway), and several prominent Canadian passengers, and fears are entertained that they have lost their lives.

It was three hours after her collision with an iceberg when, at twenty minutes past two on Monday morning, the Titanic foundered. All accounts agree that the majority of those picked up by the Carpathia were women and children, and few men appeared to have been saved by the Carpathia.

Search For The Missing
The liners Californian, Virginian, and Parisian remain in the vicinity searching for missing passengers, and although there is no confirmation, it is reported that the Parisian and the Virginian have each rescued a few survivors. However, the shipping agents have concede little hope of the safety of most of the passengers unaccounted for.

The disaster seems to have been made even more terrible by the fact that when the liner sank many lifeboats were swamped.

It is expected that wireless communication will be established with the Parisian this afternoon.

The Titanic's captain is reported drowned - Exchange telegram.

Colonel Astor Reported Missing.

New York, Tuesday. It is reported here that Colonel J. J. Astor and Captain Smith, who commanded the Titanic, are among those drowned.

Following the announcement last night of the foundering, the White Star offices were besieged by hundreds of men and women in evening dress, who drove up in automobiles, frantically demanding information - Exchange telegram.

ONLY 700 PERSONS ACCOUNTED FOR.
New York, Monday - Although the White Star Liner Company officially confirms the loss of the liner Titanic, the number of lives lost still remains problematical.

In the absence of more detailed information that is at present to hand it is impossible even to approximate in any degree of certainty.

The assassination of Archduke Franz Ferdinand on 28 June 1914 triggered a series of a catastrophic events which led to the start of World War One. Approximately 9,000 Merseysiders perished during the conflict, the youngest being Thomas James Quinn aged just fourteen. He had run away to sea to work as a Bosun's boy on board the Lusitania.

28th June 1914, Liverpool Echo

TRAGEDY OF AGED EMPEROR, HOW HE RECEIVED THE NEWS OF THE ASSASSINATION

Pathetic Scene

"Terrible, Terrible Nothing Is Spared Me"

Wife's Heroism

Her Effort To Save The Archduke

Story Of The Crime

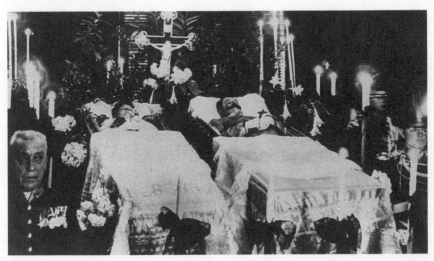

To-days messages from the Austrian capital make it clear that the assassination of the Archduke Francis Ferdinand, Heir to the Throne, and his wife, was a tragedy of lightening-like quickness. The shots were fired at close range, in a narrow street, and many near to must have failed even to hear them.

Terrible! Terrible! Nothing is spared me.

This was the pathetic examination of the aged Emperor of Austria, when he heard the awful news of the tragedy of the visit to Sarajevo, the capital of Bosnia, yesterday.

His Majesty was completely overcome, and left Ischl – where he had been staying in the hope of recovering his health – for his capital at six this morning, arriving at eleven.

Everywhere the news of the tragedy – as an addition to the already long list in connection with the House of Hapsburg – has created a tremendous sensation, and the heartfelt sympathy of the whole civilised world will go out to the Emperor to-day.

It is feared that the terrible tragedy will have a grave effect on his Majesty's health, which has been causing anxiety for some time past.

From the details of the affair as at present known, it would appear that had neither of the first two attempts proved successful, another bomb was in readiness. The Archduke warded the first attempt off with his arm, and the bomb only exploded after the motorcars had passed.

The latest messages reveal an heroic effort on the part of the Duchess of Hohenburg to save her husband.

She attempted to shield him by throwing her own body in the way of the assassin's bullet.

The Vienna correspondent of the "Matin" states that the Emperor Frans Josef has ordered the children of the Archduke Franz Ferdinand to be brought to Vienna. They will stay at Hofburg.

The *Lusitania* was built in 1906 and once was the world's largest passenger ship. The vessel was part of the Cunard Line and was en route from New York to Liverpool when she was attacked by a German U-boat on 7 May 1915. A total of 1,198 passengers lost their lives, some of whom were laid to rest in mass graves in Queenstown Cemetery, County Cork.

8th May 1915, Liverpool Echo

STRUCK WITH A BIG THUD
Wood Splinters & Column Of Water Sent Up
Scenes On Board
How Survivors Got Away In Lifeboat

Rush To Deck

Passengers Did Not Wait For Life-Belts

(From Our Own Correspondent)

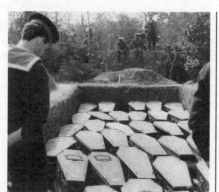

Graphic stories were narrated by survivors landed this morning at Queenstown.

Seven hundred and fifty living and forty-eight dead were brought ashore altogether. So far as can be ascertained, about 300 were taken by a tramp steamer to England.

The spectacle at Queenstown was pathetic. Many men and women were almost naked, and all were dressed in others' clothes - women with men's great coats or blankets wrapped around them,

men with uniforms kindly given them by the rescuers, some with long jackets and without trousers, and jerseys or only shirts.

Motor-cars and military ambulances took the rescued without delay to hotels and homes as the assembled crowd cheered.

A large number were seriously injured by the explosions of the torpedoes and by splinter and wreckage, as well as by their struggles in the water.

A cabin steward said the passengers were all at luncheon, and the weather was beautifully clear and calm.

"We were going about 16 knots, and were seven or eight miles south of Galley Head when we were struck by one torpedo, and in a minute of two afterwards by two more. The first staggered us and the others finished us, shattering the gigantic ship to fragments, and the Lusitania, disappeared twenty-five minutes after the first torpedo struck her.

"It was a terrible sight, but the passengers were surprisingly cool and anercited. Nearly all the first-class passengers were drowned. Most of the 500 or 600 saved were third and second class."

Three Torpedoes.

When asked if the submarine gave any warning before sinking the liner,

the steward said: "We didn't get a moment's notice. The submarine suddenly appeared above the surface on our starboard bow, and then as suddenly dived down and discharged a torpedo at us. We saw the track in the water, and it got us fair amidships.

"The Lusitania listed forward and started to settle, then the submarine discharged two more torpedoes."

"From the moment it sighted us and dived the submarine was not seen again. It went off after accomplishing its dirty work, and never attempted to save anybody.

"The two Vanderbilts, J and F (?), were first-class passengers. J. Vanderbilt went down, and I think F. Vanderbilt was drowned too.

"When the ship sank like a stone the scene was terrifying and awful. A great many were carried down at once by the whirlpool suction of the vessel. A hundred jumped overboard and cling to floating wreckage or upturned boats, which were blown off the ship by the explosions."

The Cuban consul at Liverpool came ashore with a blanket and no trousers. He sank three times and was picked up by three different boats before being landed.

Naval Cadet's Story

W. G. Elloson Myers, of Stratford, Ontario, a lad of sixteen on his way to join the Navy as a cadet, said: – "I had just come on the upper deck after lunch to play a game of quoits with two other boys. One of them, looking over the side saw a white streak coming straight through the water towards us, and shouted, "There's a torpedo coming straight at us!"

"We watched it till it struck us with an awful explosion, and we rushed down to the boatdeck. Just as we got there a huge quantity of wood splinters and great masses of water were flying around us."

A second torpedo strikes about four minutes after the first. I went below to get a lifebelt, and met a woman who was frenzied with fear and panic, and tried to calm her and helped her into a boat.

"Then, I saw a boat which was nearly swamped, got into it, and other men coming we bailed it out, and then a crowd of men clambered into it, nearly swamping it. None of us had a knife, but we found a hatchet and cut the rope lashing and got the boar clear.

Noise Not Very Great.

"We got only two hundred yards away when the ship sank bows first. Hundreds of people sank

with her, dragged down by the suction, and the cries and shrieks of these poor doomed people were appalling.

"Our boat was swamped by suction, and we had to pull hard to get well away. A whole lot of women and children went down. We saved all we could carry.

"We just saw the submarine before it dived and sent the torpedoes at us, and we never saw it rise again. The first torpedo took us amidships between the first and second funnels. The Lusitania shook and set-

tled down a bit, and two other torpedoes quickly following soon finished our ship.

"The noise of the explosion was not very great. The first torpedo burst with a big thud, and we know we were doomed. We were floating about for two hours before the first rescue steamers arrived. Before that some small boats and fishing boats came along and helped us.

The Rev. H. M. Sampson of British Columbia, said he saved himself by clinging to an upturned boat, which was righted after a

struggle. "We filled that boat with all we could rescue, and saw an object some distance away in the water," he said. "Thinking it was a vessel of some sort, we hoisted a distress signal, by tying a pair of trousers to an oar, but the vessel, or whatever it was, passed on. Big trawlers then came along and took us on board.

"When we were struck I was in the saloon and handed round lifebelts, but people didn't wait to put them on, and ran away on deck just as they were."

The end of the First World War was announced on 11 November 1918 to national jubilation. Families across the country rejoiced as relatives returned from the front for long awaited celebrations. For many others, they could only mourn.

11th November 1918, Liverpool Echo

ENTHUSIASTIC SCENES IN THE CITY; STREETS THRONGED WITH CHEERING

The Prime Minister made the great announcement at 10.20 a.m. in London. Within a minute later the "Echo," which had everything in readiness, was on sale in the streets of Liverpool giving the tremendous news for which the whole world has been waiting for days.

The papers were bought up feverishly, but for a time there was no excitement beyond cheering by the waiting newsboys and a small crowd.

People wanted to make sure; besides, four years of sternly pent-up feeling could not be released in a moment. As the news

spread in the city, flags were hoisted on the public buildings, and then cheer after cheer broke out from the gradually-increasing crowds in the streets, and every soldier or sailor was enthusiastically greeted.

Some of the newsboys were literally swept off their feet. Men rushed into

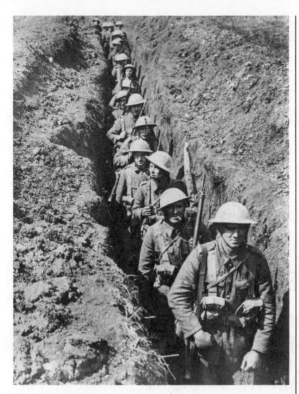

part of the large crowd, most of whom had been made aware of the good news through the medium of the "Echo."

At 11.20 the Lord Mayor, accompanied by the ex-Lord Mayor, Sir William Forwood, and other members of the City Council, appeared on the front balcony of the Town Hall, facing Castle-street.

A huge crowd, estimated as from six to eight thousand, gathered, most of them bearing Union Jacks, the Stars and Stripes, and flags of other Allied countries.

The Lord Mayor, during a temporary lull, addressed the assembly. "We had won a great victory!" he cried, and the remainder of the sentence was lost to deafening cheers. His lordship went on to extol the steadfastness of the nation throughout the terrible four years' struggle.

The speeches of Dr. Usting and Sir William Forwood were in a similar vein, and the scene of enthusiasm reached its greatest height when the venerable Sir William Forwood led the throng in the singing of the National Anthem.

shops and cafes, flourishing the paper and shouting out the good news.

There was much hand-shaking between friend and stranger. Everybody was a brother in joy.

At the Town Hall.

When the glad tiding was conveyed to the Lord Mayor he remarked that it was a matter for great congratulations and thanks-giving that the citizens should be relieved at last of the suspense of the terrible war.

His lordship was besieged with callers from half-past ten onwards. Among the first to arrive were Sir Hellenns Robertson (chairman of the Dock Board), Brigadier-General Kyffin Taylor, and the Consul for Cubs (representing the Consular Corps).

The hoisting of the flag on the Town Hall was the occasion for loud and continued cheering on the

The summer of 1919 saw the Liverpool Police opt to strike over poor pay and long hours. A constable's salary was lower than that of a general labourer and considerably less than that of a docker. Of the 1,874 members of the Liverpool City Police, 954 chose

to strike. Special constables and officers from elsewhere were brought in to keep order. Pay increases were later implemented but striking officers were permanently dismissed from their posts.

2nd August 1919

TROOPS PATROL CITY STREETS TO-DAY

Men Brought In By Motor Lorry And Billeted In St. George's Hall

NIGHT LOOTING FOLLOWS THE POLICE STRIKE

Serious Outbreaks Lead to Ransacking Of Number of Shops

BIRKENHEAD MEN JOIN THE STRIKERS

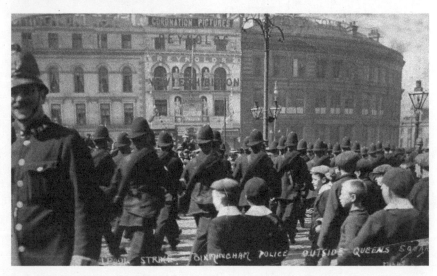

As a result of the looting which broke out in Liverpool, following the police strike, certain streets in the city—Scotland-road and Byrom-street—are to-day being patrolled by troops which were brought into the city for the emergency.

Six lorry-loads of troops first arrived. They were in full marching order, and were billeted in St. George's Hall. Other troops have arrived since.

The looting was of a serious character, and in the Scotland-road area a large amount of damage was done and a considerable quantity of material stolen by looters.

The Lord Mayor has issued an appeal to all citizens to assist in the preservation of order, and the Chief Constable is asking for recruits at once.

Volunteers for duty are asked to enrol at the Town Hall from ten o'clock this morning and daily until further notice. Existing "specials" are asked to parade for reserve duty in plain clothes, with armlets, &c., at their divisional stations at six o'clock this evening.

To-day has seen an addition to the number of strikers. A large proportion of the Birkenhead men have come out. At Birmingham sixty men came out this morning, and in Liverpool the number, according to the official figure, has increased to 700 (out of a total of 1,860). In Bootle there are 60 out, but in Wallasey only one man has struck.

Sir Nevil Macready to-day stated that there was no difficultly in filling the vacancies, and that he could get 5,000 recruits immediately. Nearly 1,000 men are out in London now.

The Liverpool Empire started life as the New Prince of Wales Theatre in the mid-nineteenth century and was at that time the city's largest such establishment. A new theatre was opened on the site on 9 March 1925 to the designs of W. and T. Milburn. Today it is Britain's largest 2-tier auditorium.

9th March 1925, Liverpool Echo

LIVERPOOL'S LEAD

TO-NIGHT'S BIRTH OF A NEW EMPIRE.
The Finest Theatre? Merseyside Latest As Best In Kingdom

Liverpool's new Empire has certainly captured the imagination of people interested in theatrical entertainment. Not only are Press critics and professional experts of wide experience unanimous in their view that the theatre is the finest in existence, but the public, too,

are anxious to make their acquaintance with the new palace of entertainment.

As already stated in the "Echo," the application for seats for the first night had been unprecedented, and many thousands of letters containing cheques and postal orders for seats have had to be returned. When the curtain goes up to-night on the big Wylie-Tate production, "Better Days," the house will be filled to its utmost capacity.

Extra Facilities

So great has been the demand that a new form of booking seats had to be instituted. Previously seats have been booked, but for this week standing room in the theatre has been bookable, and since the announcement of this new departure was mentioned in the "Echo" there has been ample proof that the system is likely to become very popular.

In order that people from outside districts may have a chance of visiting the theatre an extra matinee has been arranged, and both visitors and tradesfolk who cannot attend the evening show, can now see "Better Days," the new revue destined for the London Hippodrome, is likely to cause almost as great a sensation as the new theatre (writes an "Echo" representative, who attended one of the rehearsals). It would be unfair to "giveaway" the various features, but it may be said that in addition to some of the finest spectacular scenes Mr. Wylie has yet delayed, on the comedy side, it will be found that in the burlesques, one of the acts in particular, has more intelligence and wit combined with beautiful costuming than has yet been seen on the revue stage.

A MAMMOTH TASK.

The putting together of a revue of this scale is a gigantic task. In the case of "Better Days" the task has been greater than usual, as only latterly has it been possible to rehearse in the theatre. The multitude of scenes have had to be rehearsed in bits, and one finds some girls practising a new bit of business there, electricians, those most important persons in a modern theatre, being instructed in the various lighting effects concerned, and all accompanied by the bang-bang of workmen's hammers. To evolve order out of this chaos would unnerve most people, but Mr. Maxwell Stewart, Mr. Wylie's chief lieutenant has stuck to his task manfully; he has spared no one, least of all himself. During the course of the rehearsals he has been working day and night. This is a side of "entertainment" that we who sit comfortably in our stalls are apt to forget.

To-night, however, Mr. Stewart and Mr. Wylie and their assistants will be able to feel that their work has been well done, and a production worthy of the memorable occasion has been devised.

A CELEBRATION BALL.

To celebrate the opening of the Empire Theatre a supper and ball is to be held at the Midland Adelphi to-morrow night (Tuesday). The function promises to be the most brilliant social affair of the season, and many distinguished people, not only from Liverpool but from London and other parts of the country, are to attend.

All the artistes taking part in "Better Days" will be present, and various novelties are being devised so that the ball may be a gay revel as well as a social

function. Supper will be served at 11.30 p.m., and the dancing will continue until 3 a.m.

The Great Strike of 1926 affected various industries up and down the county, but it was coal miners who took the lead. At the height of the unrest it was estimated that 1.7 million workers took part. Negotiations between the Trade Unions Congress and the Government led to an end to the strike on 12 May. Labour Leader Ramsay MacDonald is seen here with union leaders entering the TUC building in London for crisis talks.

12th May 1926

"STRIKE OFF"

How The Great Strike Ended

ALL ROUND CLOCK

Story Of A Day of Thrills

HOW IT HAPPENED

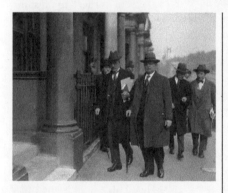

Speedy Hours In Dash For Peace

Soon after one o'clock to-day the joyful news flashed out.

"Strike Off"

The actual dramatic scenes which preceded the gladsome announcement are soon told.

First, Sir John Simon, in the Commons, during Tuesday night had said strongly that he felt that both sides should drop all ideas of "fighting to a finish," and that he would move definitely that if three conditions were complied with the Government ought to announce willingness to give the subsidy for a short period.

The three conditions he had in mind were:-

(1) Calling off General Strike;

(2) Work in mines at old rates;

(3) Government to legislate to carry out the Commission's findings.

A final essential condition was that owners and miners should give an undertaking to negotiate on the basis of that report without excluding anything which it contains.

(Note.–This would include wages.)

These proposals caused great excitement at Eccleston-square, the Labour headquarters. They were discussed by the Miners' Executive, the T.U.C., and Parliamentary Labour Party Executive until after midnight.

Small Hour Meeting

The T.U.C was in conference until 1.50 a.m., and then adjourned. Cabinet Ministers under the Premier, were at Downing-street, and were informed that the T.U.C. would arrange a meeting later that (Wednesday) morning.

Meanwhile there had been comings and goings among the Premier and the Cabinet negotiators, and other Ministers were also severally consulted.

Following these midnight activities Labour leaders, Ministers, miners, T.U.C. and Cabinet had separate conferences this morning. Then at noon the full T.U.C. Council visited the Cabinet.

Sir Herbert Samuel had previously been busy, and Mr. Kenneth Lee and other Commissioners were in London in response to an urgent call.

The negotiating Ministers already assembled at Downing-street were joined by Mr. Churchill, Mr. N. Chamberlain, the First Lord, and Sir W. Evans.

The T.U.C. representatives included Messrs. Pugh, Swales J. H. Thomas, M.P., Ben Tillett, and Miss Bondfield.

The Good News

After a sitting of about an hour the dramatic announcement came through – A Settlement. But not before an incident which seemed to blast all hopes.

Mr. J. H. Thomas came out, and as he passed through the waiting pressman he appeared on the verge of collapse.

Asked if there was any news he at first shook his head, and then added, in trembling, "Nothing." He was assisted across the road by two secretaries of the N.U.R to his car. He repeatedly passed his hand over his head, and appeared to be ill.

Then came the splendid note of peace. "Strike off" was spread as by a thousand tongues; the words reached the wires, and the newspapers and agencies flashed it all over the world.

Official Announcement

The next phase was "How?" Briefly word passed that the T.U.C. had "called it off to-day." Then, as quick as could be came the full official announcement:-

The Prime Minister, who was accompanied by the Minister of Labour, the Secretary of State for India, the Minister of Health, Secretary of State for War, the First Lord of the Admiralty, and the Secretary for Mines, received the Members of General Council of the Trades Union Congress at 12.20 to-day at No.10, Downing-street.

Mr. Pugh announced on behalf of the General Council of the T.U.C. that the General Strike was being terminated to-day.

T.U.C. Announcement

Mr. Walter Catrine also made the following statement on behalf of the General Council of the T.U.C.

"In order to resume negotiations, the General Council of the T.U.C. has decided to terminate the General Strike to-day, and telegrams instruction are being sent to the secretaries of all affiliated unions.

"Members, before acting, must await the definite instructions from their own Executive Council."

This was signed by Mr. Pugh, Mr. Bromley, Mr. Citrine, and others.

Previously, to the Press, Mr. Cook had said that if the strike was called off the miners would call a delegate conference for Friday.

The legendary Everton footballer Dixie Dean scored a record sixty league goals in the 1927/1928 season. A statue was unveiled in his honour outside Goodison Park in May

2001. A year later, he became one of twenty-two players inducted into the inaugural English Football Hall of Fame and remains an iconic figure in Everton's sporting history.

5th May 1928, Liverpool Echo

THE CHAMPIONS AT PLAY: EVERTON AND ARSENAL WIND UP AN HISTORIC SEASON

Legendary Footballer Dixie Dean Scored a Record 60 Goals, 1927–28

Magnificent weather graced the final act of the 1927–28 season at Goodison Park today, when Arsenal visited Everton in a match that promised to be historic because it meant Everton stood No.1 in the League on August 26 last year.

It was Charlie Buchan's final match in football history.

It was Everton's third League championship, it was Dean's best season ever, and opened the possibility of Dean breaking all English League records by getting three goals to-day.

Thus, the game had many aspects and much appeal. It was not surpris-ing that 50,000 spectators looked at the handsome League trophy that was in the centre of the directors' box.

There was a gentle breeze, much animation, and an increase of the police force, the last named being charged to keep the crowd from run-ning across the pitch at the end of the game when the presentation was being made.

"WHERE THE COLOURS"

An entrance from Bullens-road had been erected for the first time in the history of the club, so that mounted police could be brought into the ground at any given moment they were required.

A spectator shouted to the Everton officals "Where are the colours?" Everton acted on the hint, Mr. Tom McIntosh, their secretary, tying the club colours on the trophy.

Mr. W. C. Gull, the chairman, opened proceed-ings by asking the crowd through the microphone to keep their places after the match.

There was a stupendous cheer for Cresswell and his men, and the warmth of the welcome for Buchan showed the public were crazy after this inspiring turn round in the score sheet.

It was all very simple in the making. The first point was from a corner taken by Critchley. Martin turned the ball on to Dean, who headed it to the extreme left-hand corner. This was the sec-ond chapter at the second minute.

The third excelled all others. Dean was running through when the long-legged Butler crossed him. It was an accidental collision – to the referee it was a trip and the consequence was that Dean was able to rise from the ground and take the penalty kick successfully and well.

Three goals in the first five minutes of this championship act was all to the joy of the crowd. It was a fitting start to

a fatal game – fatal in the sense that Dean was now wanting but one goal to put him top of England in the League section in the course of forty odd years of League football.

The 1931 murder of Julia Wallace continues to baffle criminologists to this day. On 20 January Julia's husband Herbert claimed to have discovered her battered body at their home at No. 29 Wolverton Street, Anfield. He was found guilty of her murder, but the case went on to make legal history when his conviction was overturned by the Court of Criminal Appeal. It was the first time an appeal had been allowed after a re-examination of evidence.

2nd May 1931 Liverpool Echo

'STRIKING VIEWS ON THE WALLACE CASE'

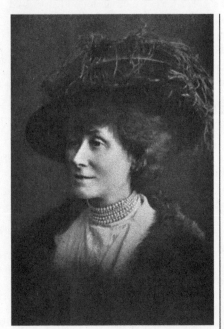

Reactions to the Julia Wallace Case

While interest in the "Wallace Case" until the verdict was only local, the issue raised by the Appeal Court's decision reversing the jury's finding are today discussed far and wide.

In London the appeal aroused wide legal as well as public interest, and in Liverpool the eagerness for the opinion of the High Court Judges was intense. We give below to-day's views on the Appeal decision.

Mr. Wallace stayed in London overnight, and will probably return to Liverpool by road early this evening.

The cost of the defence in the trial and the appeal is not disclosed, but a legal authority told the "Echo" that to cover everything he thought £1,500 would be about the figure. The fund for the special costs of the appeal is not yet closed, and at present is below £500.

NEWSPAPER VIEWS ON THE COURT'S DECISION
In Other Days

Twenty-five years ago, before the Court of Criminal Appeal was constituted this conviction would have had to stand ... It is gratifying to know that in these days there is a Court which, although it is not a Court of rehearing, can prevent such a miscarriage of justice as has occurred in

this case . . . Mr. Justice Wright summed up, as lawyers put it, "for an acquittal." The only surprise is that he did not at Liverpool withdraw the case from the jury and direct as acquittal. If Wallace could have been properly convicted on this evidence, any innocent man might have been convicted for a crime of which he knew nothing – "Yorkshire Post."

Court's Value Vindicated

The verdict of the jury, as we said at the time, was a surprise, particularly in view of the summing up of the judge, and the possibility of a miscarriage of justice was widely feared. The Court of Criminal Appeal has been criticised for interpreting its own functions narrowly. But, at any rate, its judgement yesterday is drastic and signally vindicates its value as a court of appeal. – "Liverpool Daily Post"

The Police

So strong was the feeling in Liverpool that prayers for a true judgement were publically offered in Liverpool Cathedral, and in another church a collection was made in aid of the fund raised to meet the costs of the appeal.

The Lord Chief Justice stated that, so far as he could see, there was no ground for any imputation on the fairness of the police and before such authority as that the public will be wise to bow its head.

It is very rare indeed for an appeal to be so successful on the ground of a wrong decision by the jury on the facts. On account of that rarity the acquittal of Mr. Wallace deserves particular notice. It offers a striking example of the efficacy of the Court of Criminal Appeal, and of its value as a protection against the errors which even the justest intentions and the most scrupulous care are not always able to prevent. – "The Times."

Proof, Not Rumour

Public confidence will be reassured by the unanimous decisions of the Court of Criminal Appeal. Rex v. Wallace reaffirms the basic principle of English law, that a man is innocent till he is *proved guilty in accordance with the laws of evidence.*

Juries, inexperienced in methods of legal proof, are too ready to jump to conclusions where their minds are affronted by the crime being of exceptional brutality.

The utterance of the Lord Chief Justice was timely and to the point when he said: "*Suffice it to say that we are not concerned here with suspicion, however grave, or theory, however ingenious.*" – "Daily Herald."

Juries Not Infallible

No doubt, a case – of sorts – was in fact presented; a case largely built up on an unjustifiable initial assumption, yet still, in its poor thin way, a case. We can see no justification, however – we can see hardly any excuse – for the jury's verdict ... Juries are not infallible. This Liverpool jury would seem to have been very much too ready to join with the police in asking, "If he did not do it, who did?" and too ready to draw inadmissible conclusions from its own incapacity to answer that riddle . . . What must be said is that for once in a way suspicion was too readily accepted as the equivalent of proof. The verdict was against the weight of evidence. – "Birmingham Post."

Juries Not Sacrosanct

The decision ... is the more notable in that a Court of Appeal is very slow to upset a jury's finding on the facts. But a jury's verdict is not sacrosanct ... It is to be hoped that the action taken by the Court of criminal Appeal will have the effect of impressing on juries in general the extraordinary gravity of the task which they are summoned to perform.

It is very rare indeed for an appeal to be successful on the ground of a wrong decision by a jury on the facts. **Finding the Criminal**
The Appeal Tribunal has set free a victim of injustice with his character cleared, a character which, if he had nothing to rely upon but the prerogative of pardon would never have been relieved of the stigma of conviction on a jury's verdict.

But the finding of that tribunal has done more. It has created the presumption that there is still at liberty and unsuspected a monster of wickedness who, in addition to planning and carrying out a cold-blooded and brutal murder, sought by a cunning device – that of the fraudulent telephone call, to which the prosecution attached so much importance – to direct suspicion upon his victim's husband.

That's a matter to which the attention of the police authorities concerned is urgently directed by the outcome of this extraordinary prosecution. – "Daily Telegraph."

A Very Small Band
Three of our foremost judges ... found that there was not sufficient evidence to send a man to the scaffold. They upheld the appeal made on behalf of the prisoner. To-day he is a free man – one of the very small band of living people who, having faced death, have found respite ... We ... can share with him that feeling of thankfulness which must be his in the knowledge that in England, at any rate, justice ever sifts and weighs the evidence. – "Daily Dispatch."

Undoubted Propriety
A man found guilty of murder by an English jury and condemned to death by an English judge had the remarkable experience of leaving an English court of law a free man. It was a remarkable experience because in this country a miscarriage of justice on a capital charge, though not unknown, is so rare that the chance of escape after sentence is not much greater than that of winning a national sweepstake . . . But no one who has studied the evidence at the Wallace trial or the arguments put before the Appeal Court with so much force and ability by Mr. Roland Oliver, Wallace's council, will be inclined to doubt the propriety of the decision. – "The New Chronicle."

No Reflection
Uncertainties and anxieties pressed on the public mind. We are convinced entirely of the necessity for capital punishment. But the extreme penalty can only remain so long as the public are sure that, humanly speaking, no innocent man runs any risk of execution. The verdict of the Court of Appeal strengthens public confidence in the administration of the criminal law and casts no reflection of any kind on judge, jury, or police. As for that unusual feature of the case the intercessory prayers in Liverpool Cathedral, we must admire the courage and sympathise with the feelings of the Bishop. But we are not compelled to approve the form of all the prayers. – "Morning Post."

The Cathedral Prayers
A good deal of doubt will be felt as to the special intercessions which were offered in connection with this case in Liverpool Cathedral on Sunday. Prayer on such occasions is very right and proper, but should it not be prayer in private? – "Daily Mail."

The construction of the Metropolitan Cathedral began on 5 June 1933 to the impressive designs of the architect Sir Edwin Lutyens. It was to feature the largest dome of any church in the world and stand as a truly awe-inspiring addition to the cityscape. Spiralling costs and the outbreak of war saw plans for the cathedral scaled down. It was finally completed to the new design of Sir Frederick Gibberd in May 1967. It has become affectionately known as Paddy's Wigwam.

5th June 1933, Liverpool Echo

TO-DAY'S CATHOLIC CATHEDRAL CEREMONY

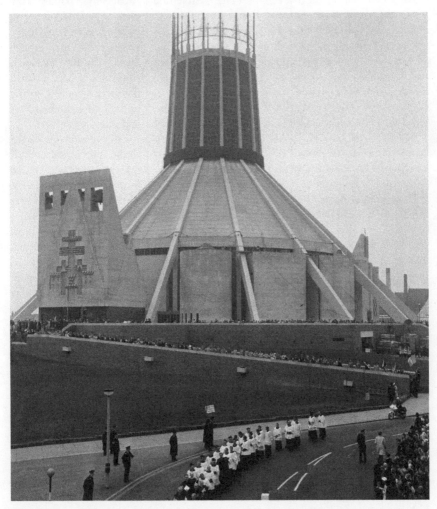

"Arresting Act of Faith"
Papa Legate's Impressive Address At Laying Of Foundation Stone Message Dropped From The Skies
Archbishop Downey's Thought For Vast Multitude of Worshippers.

Impressive Scenes And Ceremonials

In glorious sunshine supremely fitting the sacred occasion, cardinal and archbishops, bishops and humble monks, the Lord Mayor and civic leaders, wealthy pilgrims from overseas, and poor dwellers in the narrow byways that bound the site to-day assisted at the laying of the foundation stone of the Roman Catholic Liverpool Metropolitan Cathedral.

Long before noon the congregation in the enclosure had reached nearly 40,000. It was announced that, in view of the excessive heat and the broken condition of the ground, the Archbishop would not consider it an irreverence if the people wore their hats and remained seated.

A quarter of an hour before the arrival of the Papal Legate one of two or three aeroplanes which had been flying round the site suddenly sweeped down to within a few feet of the top of the Altar and dropped a blue and white parachute with a package attached. The pilot of the machine was Colonel the Master of Sempill and the package was addressed to the Papal Legate. The package was dated "Over Liverpool, 5th June 1933." The parachute was dropped accurately at the foot of the Legate's throne. It was picked up by attendants and handed to Cardinal MacRory as he took his place.

With solemn and deeply impressive ritual his Grace the Archbishop of Liverpool performed the ceremony of blessing and laying the foundation-stone, following which His Eminence Cardinal MacRory, the Papal Legate, made his address.

The Papal Legate in his address, said: This magnificent Cathedral, the foundation stone of which has just been laid by your brilliant Archbishop, as it rise to Heaven in all its strength and beauty, will be a symbol of your faith and in this present world conditions will also be a great public act of faith in the existence of God and in the reality of all the supernatural and never was there a time when a great arresting act of faith was more necessary.

Messages from all over the world—from Brisbane, which is building a great domed cathedral; from Africa, and the United States—have poured into Archbishop's House, congratulating Dr. Downey on to-days historical event.

The Bishop of Liverpool, Dean Dwelly, Professor Abell, and others watched the ceremony from a roof in the University buildings opposite the site.

The ceremonies lasted about four hours and all that time some 28,000 people stood in the streets, while over 40,000 were on the site. Ambulance detachments were busy, and it was estimated that more than three hundred people required treatment up to three o'clock, among them being Monsignor Godfrey, Rector of the English College in Rome, and Father Henry Keane, Provincial of the Jesuits. At Mount Pleasant Convent he recovered, and was able to leave for St. Francis Xavier's College.

The Philharmonic Hall had originally opened in 1849 and could accommodate over 2000 patrons. On 5 July 1933 a terrible fire tore through the building to such an extent that it could not be saved. Herbert Rowse was commissioned to design a new venue

on the same site in Hope Street, which opened in the summer of 1939. Today the Philharmonic Hall hosts approximately 250 events per year and is a splendid example of Art Deco architecture.

6th July 1933, Liverpool Echo

NEW HALL OF MUSIC ON SAME SITE

Future of the Philharmonic

ANOTHER HALL TO BE BUILT

Insured For 100,000

SIDELIGHTS ON GREAT NIGHT FIRE

Valuables Saved

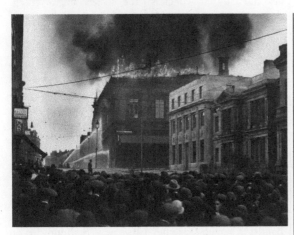

Everyone interested in music in Liverpool, and indeed in the city's possessions generally, will learn with relief, to-day, that the fire disaster which reduced the famous Philharmonic Hall to a shell, last night, will not mean a permanent loss to the city.

The Echo was informed, on the best authority, to-day, that there is no question but that another hall will be built on the site of the old one.

It is understood that the hall was insured for £100,000, and the only question in the minds of the committee to-day is what form the new hall shall take.

The old hall was unique in its acoustic properties, and it may be decided to attempt to reproduce it again within the shell, which is all that is now left standing. In this event, the old-fashioned, high-backed gallery seats, long a source of worry to the society, would, of course, be modernised.

On the other hand it may be decided to construct a modern hall on an entirely new plan.

But it is generally felt that Liverpool must not be allowed to lose such an amenity as the Philharmonic Hall and contingently the 95-year-old Philharmonic Society.

How It Started

It is now felt to be practically certain that the fire originated between the double roofs of the building, but the actual cause may never be known, as it is highly probable that any evidence which might have cleared up the matter has been destroyed.

The Liverpool Fire Brigade are continuing their investigations.

Smouldering To-Day

Mr. W. J. Biley, secretary of the society, informed the *Echo* that the committee was considering the whole question this afternoon, when the future policy of the society is to be discussed.

At eleven o'clock this morning the ruins were still smouldering, and salvage corps men were in attendance. The two main arches spanning the length of the hall have been completely destroyed, but the fine decorative arch covering the cross boxes remains intact. The valuable music library is irretrievably lost.

The Autograph Book

Included in this library were numerous scenes and orchestral parts which have been in the possession of the society for upwards of half a century. Unfortunately, a considerable proportion of these are irreplaceable.

The safe, containing the historic autograph book, with the signatures of all the famous artistes who have appeared at the society's concerts from the day of its foundation, fell through into the basement, but when it was opened, this morning, it was found that, apart from a certain amount of charring of the covers and the melting of the glue in the binding, the sheets themselves remained undamaged as also did a unique cut-glass decanter in the form of a harp, with gold stoppers, which, though still hot, had not been damaged.

Pictures Rescued

Fortunately, also, the splendid collection of signed portraits of celebrated artistes who have appeared at the concerts had been saved and temporarily housed in the basement of the Myrtle-street Baptist Chapel, together with two fine specimens of double basses belonging to Mr. E. Stanfield and Mr. Rowland.

The pictures were saved in the early stages of the fire, but the two double basses, which were in the basement under the stage, passed through the fire unscathed, and were recovered the morning by salvagemen.

Mr. Riley informed the *Echo* that the hall was locked up last evening as usual at five o'clock, and the electricity turned off at the mains.

The committee is concerned at the serious loss which will fall upon the members of the orchestra if the concerts have to be abandoned this season and every effort will be made to minimise hardship. Only yesterday the contracts for the coming season were sent out.

The suggestion has already been made that the society might engage St. George's Hall for the coming season's concerts, but it is doubtful whether this will commend itself to the committee in view of the difficult acoustic properties of St. George's Hall in regard to orchestral music.

Stadium Concerts?

An interesting possibility is the fact that next season concerts will in all probability be held in the new Stadium in St. Paul's-square. Inquiries to this effect have already been set on foot. It will be recalled that when the old Stadium in Pudsey-street closed, endeavours were made by the management to stage boxing matches at the Philharmonic Hall,

but at the last moment the Philharmonic Committee decided against this.

A particularly unfortunate feature of the fire is the total loss of the magnificent new organ which, erected by Messrs. Rushworth and Dreaper at a cost of over £3,000, was only completed a year or two ago.

The Queensway Tunnel was opened on 18 July 1934 by King George V. 1700 labourers were employed in its construction and at the time of its opening it was the longest road tunnel in the world.

Wednesday 18th July 1934, Liverpool Echo

THE OPENING OF QUEENSWAY TUNNEL

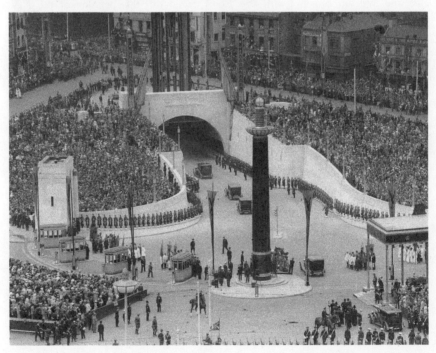

Here is the story of the Liverpool Tunnel ceremonial, for which a crowd of quite 150,000 to 200,000 had assembled.

Just before the slowly-moving Royal procession came down London-road thousands of voices around Kingsway had joined in the singing of the first verse of Elgar's "Land of Hope and Glory," accompanied by the band of the Liverpool City Police. It was an impressive few minutes, made the more exciting by the momentary deathly silence which followed as the last notes trailed away.

Then the murmuring of the crowd swelled into rolling breakers. Everyone stood on tip-toe, people in the windows craned their necks and all eyes were focussed on the corner of London-road. A gradually-increasing roar heralded the nearness of the Royal procession.

EARLY MORNING VIGIL

Thousands in the crowd had been waiting around St. John's Gardens, St. John's-lane and William Brown-street since the early hours of this morning. Many had brought camp-stools and nearly all were equipped with the material for at least one meal.

An hour before the Royal procession was due there was no standing room available. Scenes reminiscent of the first Armistice day were seen over the west area surrounding the site. Everywhere was literally black with people.

In front fronted by the black granite beacon was the Tunnel mouth, grouped around with golden pylons carrying decorative banners in gay colours. Similar banners were flaunted from the classic front of the public buildings in St John's-lane.

The most striking and original form of "decoration" was that formed by a party of over one thousand city elementary school-children who, dressed in frocks and hats of vivid colours, carefully grouped transfigured the steps of the Museum, covering the whole with a "garden" of living colour.

It was a human floral bouquet which, banked tier upon tier on the parapet of the Museum, drew exclamations of delight from thousands as the eye fell on them.

When the King's car, with the Royal Standard fluttering on a miniature masthead, appeared at the foot of London-road, the "garden" came to life as the "child-flowers" waved and cheered ecstatically.

The Queen was obviously much impressed by the sight, and drew the King's attention to the children.

Their Majesties were received at the Tunnel entrance by the Lord Mayor and the chairman of the Mersey Tunnel Gentlemen in Waiting. All took up their appointed positions on the Royal dais. On their Majesties taking their seats, the Lord Mayor then tendered the city's welcome, saying:

"May it please Your Majesties:–On behalf of the citizens I extend to Your Majesties a hearty welcome on this Your memorable visit to our city.

"Your presence here to-day will give encouragement and inspiration to our people.

"Liverpool has always been characterised for its intense devotion to the Throne and Constitution and we are proud to say that the loyalty and regard for Your Majesties never stood higher than they do to-day.

"May I express the sincere hope that Your Majesties' visit to this city, on the occasion of this opening of the New Mersey Tunnel, to be named "Queensway," after Her Majesty the Queen will afford Your Majesties pleasure and satisfaction.

"I will now ask Sir Thomas White, the Chairman, to read the loyal Address of welcome of the Mersey Tunnel Joint Committee."

MERSEYSIDE LOYALTY

Sir Thomas White then read :–
"To the King's Most Excellent Majesty
"MAY IT PLEASE YOUR MAJESTY
"We, Your Majesty's loyal subjects, the Members of the Mersey Tunnel Joint Committee, beg leave to approach Your Majesty and her Majesty the Queen with an expression of our dutiful homage and our gratification at the

high privilege of welcoming Your Majesties on this memorable occasion of your Visit to Liverpool and Birkenhead, and we assure Your Majesties of our deep loyalty and affection.

"It is a matter of great gratification to the Citizens and Burgesses that Your Majesties have once more evinced deep interest in all that concerns the welfare of your people by your presence here today for the purpose of opening to public traffic the largest sub-aqueous Tunnel in the World – a great engineering work of national character and importance which has been constructed to meet the ever-growing transport requirement of the Port of Liverpool and an event of great importance to our trade and local history.

"Your Majesties' presence on this eventful occasion is regarded by the Citizens and Burgesses of Liverpool and Birkenhead as another example of the profound interest taken by Your Majesties in all great projectsharing for their object the welfare and prosperity of Your Majesty's subjects.

"It is our heartfelt prayer that the Almighty may continue to bestow every blessing upon Your Majesties and that Your Majesties may both be long spared to this Great Empire, to advance the happiness of which your best endeavours are always directed.

"Given under the Common Seal of the Mersey Tunnel Joint Committee this eighteenth day of July, One thousand Nine hundred and Thirtyfour. -Thomas White (Chairman), Walter Moon (Clerk)."

The King then replied.

THE KING'S SPEECH
The King, in declaring the Tunnel open, said:-

"I thank you for your Address of welcome to the Queen and myself.

" It is a deep pleasure to us to come here to-day to open for the use of men, a thoroughfare so great and strange as this Mersey Tunnel, now made ready by your labour.

"In some other seaports channels and estuaries have been bridged with structures which rank among the wonders of the world. Such bridges stand in the light to be marvelled by all. The wonder of your Tunnel will only into the mind after reflection.

"Who can reflect without awe that the will and power of men, which in our own time have created the noble bridges of the Thames, the Forth, the Hudson, and Sydney Harbour, can drive also tunnels such as this, wherein many streams of wheeled traffic may run in light and safety below the depth and turbulence of a tidal water bearing the ships of the world?

"THIS MIRACLE"
"Such a task can only be achieved by the endeavours of a multitude. Hundreds have toiled here; the work of many thousands all over this country has helped their toil. I thank all those whose efforts have achieved this miracle.

"I praise the imaginations that foresaw, the minds that planned, the skill that fashioned, the will that drove, and the strong arms that endured in the bringing of this work to completion.

"May our peoples always work together thus for the blessing of this kingdom by wise and noble uses of the power than man has won from nature.

"I trust that the citizens of this double city, so long famous as daring traders and matchless seaman, may for many generations find profit and comfort in this link that binds them.

"I am happy to declare the Mersey Tunnel open. May those who use it ever keep grateful thought of the many who struggled for long months against mud and darkness to bring it into being."

The coronation of King George VI on 12 May 1937 was a great civic occasion which saw an array of parties and revelries take place across the city.

12th May 1937, Liverpool Echo

L'POOL'S GREAT DAY
Peak Of Civic Celebrations
COLOURFUL SCENES
Solemn Ceremonies At The Cathedrals
POMP AND SPENDOUR

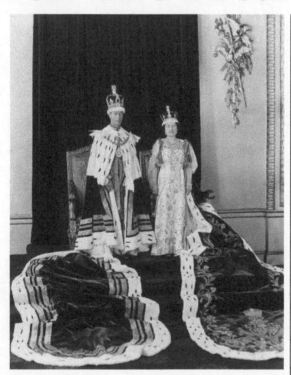

To-day Merseyside celebrated the most colourful occasion of a "civic week" more truly civic, for all its national object, than has ever occurred in the city's annals, and not even the grey skies of early morning, nor the threatening showers, were able to quell, or even qualify, the national holiday spirit, nor to dim the gay colour of Liverpool's homage to the Throne, and its gracious occupants.

The civic banner was hoisted full mast, with moments of solemn dedication in the two Cathedral churches, the parish churches, and free churches, gaily dressed vessels on the river; pomp and splendour in Town Hall; street procession and park display; with salute of guns; with ancient ritual as typified by the "King's Champion" ceremony; with martial music in the air.

For though Merseyside's eyes may have been – figuratively speaking – set on Westminster Abbey with eyes of the whole nation and Empire – her ears save for that brief interval when we were able to play an aural part in the solemn Abbey ceremony – were

attuned to the music that filled the streets.

MUSIC OF CHURCH BELLS

"Ringing of bells, 9–11a.m." said the official programme, but it must have been a full half-hour before the advertised time that the parish churches gave forth to the drowsy holiday-makers in the suburbs that this was not as other days are.

Not for twenty-six years, unless one excepts that memorable night in 1918 has the music of church bells so filled the air as it did to-day , and never, for certain, have the grey streets of the port and city worn such festal array.

Many of the poorer areas had deferred their preparations until the eve of the great day, and passers-by in Islington and Scotland-road rubbed their eyes to-day at the overnight "transformation scene."

Although mist overhung the Mersey this morning hundreds sought the stage sand promenades on both banks in order to view the river spectacle provided by the presence of six representative Liverpool liners decorated and moored line ahead in midstream. The vessels are the Aba (Elder Dempster Line), the Mandasor (Brocklebank), Nova Scotia and pacific President (Furness Withy),

the Alfred Holt liner Sarpedon and the Cunard White Star steamer Scythia.

The tender Skirmisher, gaily beflagged, took her first complement of Liverpool nurses, who were bound for a tour of inspection of the Scythia. To-night the vessels will be illuminated by a myriad coloured lights, with the lines of the anchored ships picked out in fairy lights. There will be river cruises to view the display at 11 p.m.

CITY PROCESSION

Although the Lord Mayor (Alderman William Denion) and the Lady Mayoress of Liverpool were present by invitation at the Abbey ceremony, many ex-Lord Mayors took part in the civic procession which, headed by the deputy Lord Mayor (Councillor R. J. Hall), marched from St. George's Hall to Liverpool Cathedral and to the site of the Metropolitan Cathedral to attend the religious services that inaugurated Merseyside's day of rejoicing.

The procession, which was watched by some thousands of townsfolk, who lined the route by way of Lime-street, Renshaw-street, Leece-street, and Rodney-street, was a colourful one.

The Lord Mayor's state coach, with liveried coachmen and footman, preceded it to the Cathedral. Inside it were the Deputy Lady Mayoress (Miss Margaret Hall) and Mrs. Edward Denton, daughter-in-law of the Lord Mayor.

At the head of the procession was the gaily-twirling staff of the band-major of the 2nd. Battalion the King's Regiment (Liverpool), the bandsmen marching with a precision worthy of Guardsmen, and resplendent in scarlet and gold.

Following were the members of the Consular Corps, many in the military and naval uniforms of their countries. Then came the Deputy Lord Mayor (Councillor R. J. Hall), and the Town-clerk (Mr. W. H. Baines), the aldermen and councillors, many of them ex-Lord Mayors.

They were preceded by the civic regalis –the gilt Maces, Spade and Sword of State which have been in the city's possession for over a century. The police band and the band of H.M. Schoolship Conway, with about 120 cadets of the ship followed.

At the point where Leece-street and Rodney-street intersect, the Catholic members of the procession, headed by Colonel Sir John Shute, M.P., branched off to the

left to attend the special Mass at the site of the Metropolitan Cathedral, while the main body wheeled to the right along Rondey-street.

On reaching Mount-street, the procession was joined by the boys and girls of the Bluecoat School, Liverpool's oldest charitable foundation, who, graded in height and headed by tiny children, made a bright picture as they marched at the rear, headed by their own bugles and drums. The Bluecoat children deserved the special clap they received from the crowd of onlookers outside the Cathedral.

DIGNITY AND PAGEANTRY

Dignity and pageantry were mingled in the ceremonies at the cathedral and within it purlieus. The civic procession was received from the Dean and Chapter and the members of the executive committee responsible for building and completing the Liverpool Cathedral, whilst the band of the 2nd Battalion King's (Liverpool) Regiment played the Homage March.

Parts of the service synchronised with those at the Abbey. There was the Invocation raised from of old at the Coronation of Kings of England, and the Recognition, so that

here in Liverpool loyal citizens signified their joy by repeated acclamations of "The King. God save the King!"

Appropriate music and prayers were included, and just before the end of the service within the Cathedral the Dean preceded the Chapter and the Deputy Lord Mayor and company to the Founders' Plot where a thick line of people awaited the opening of the outdoor service.

AT THE FOUNDER'S PLOT

There was a colourful setting for this service at the Founders' Plot. The regimental band made a vivid splash of colour framed in the Cathedral entrance; the Conway cadets, with their white-topped hats attracting the eye, were lined up on the high balconies, and on other balconies were the uniformed figures of the Boys' Brigade, whilst drawn up behind the Cathedral wall alongside the Founders' Plot were the boys and girls of the Bluecoat School.

In the immediate front were the members of the Union of Girls' Clubs forming the great choir. Their white dresses and cloaks and hats of royal purple and red made a brave show against the brick-work.

After introductory remarks by the Dean, the sweet strains of the Acclamation Anthem, "Zadok the Priest and Nathan the Prophet anointed him King... floated over the heads of the expectant crowd. Drums rolled and trumpets sounded. The styles of the King were read, and then the Conway cadets, from their lofty site, shouted "Vivat Rex Gorgious! Vivat! Vivat! Vivat Vivat Reginah Elizabetha!"

SOVEREIGN ACCLAIMED

The crowd listened with rapt and reverent attention as the Dean and the Deputy Lord Mayor led the company on the Founders' Plot in the recital of "Their Loyalties" and then followed the individual declarations of allegiance by the Conway Cadets, the Bluecoat School, the Boys' Brigade, the great choir, until finally everyone present, with one voice, paid their allegiance. These ceremonies were punctuated by the singing of "God Save The King - Long Live The King - May The King Live for Ever," by the choir, and as a finale the Dean cried "Thus the citizens of Liverpool acclaim the Sovereign Majesty of George VI on his Coronation Day, giving thanks to God, unto

whom be all praise and honour."

All then sang the hymn, "Praise God From Whom All Blessings Flow."

THE KING'S CHALLENGER

The crowd now awaited the old-time pomp and pageantry of the "King's Challenge." The Boys' Brigade shouted "The Challenger, three times three, and with their band playing at their head, they led into the arena before the Founders' Plot the Challenger, escorted by his trumpeter herald, and his two attendants on their chargers. Inspector R. Binnington, of the Liverpool Mounted Police, made a brave and cavalier figure on his caparisoned charger as "The Challenger." The blood-red crest of plumes in his steel helmet waved in the breeze, and his full suit of mediavel armour glinted dully.

He held his Crusader's sword at the salute, and Playfair, his mount, pranced proudly. The Herald, with hat doffed proclaimed the Challenger threw down his gauntlet.

It lay on the ground for a short time, and then the Herald delivered it back to the Champion. The trumpeters sounded "The Clearance," and then voices roared "Long Life To His Majesty."

The Champion delivered the script to the Deputy Lord Mayor, whereupon the Under Sheriff, in the name of the High Sheriff of the county, proclaimed the loyalty of the County Palatine, "God Save the King."

Drums rolled, the trumpeters sounded the fanfare, and, with the band playing everyone sang "God Save the King."

Liverpool had declared its homage and its allegiance.

ROYAL SALUTE OF GUNS

The Mersey Division of the Royal Naval Volunteer Reserve fired a Royal salute of twenty-one guns from the new Pier Head gardens, Liverpool at noon to-day.

A guard of honour marched, with fixed bayonets, from the depot ships Eaglet and Irwell. Three guns manned by a field battery commanded by Lieutenant E. N. Wood, fired the salute.

The guard of honour was under the command of Lieut. J. R. Walker, Capt. E. Elgood, who commands the Mersey Division, was also present.

A salute was also fired at Sefton Park, where the 353rd battery had taken up its station on a treelined bank overlooking the boating lake. After the first gun the swans, preserving as much dignity as they dared, were paddling in line abreast for the shelter of the bend in the lake. The ducks just took to their wings.

Although one "dud" turned up in the coemplement of "blank" shells the neighbouring gun in the battery of four took up the cue in the split part of the second.

CENTRAL HALL SERVICE

A United Free Church service was held in the Central Hall, Liverpool to-day, conducted by the Rev. H. C. Lewis, president of the Merseyside Free Church Council.

In his address the Rev. J. T. Wilkinson, the ex-president, said they had to remind themselves on this Coronation day of the place of our people amidst the nations of the world. We were a people whose institutions still preserved a high measure of civil freedom and personal liberty, won at great cost by our fathers for our heritage. We were still a people of representative government, and constitutional authority and to-day signified a hallowing of that power. But amidst the rejoicing and festivities – which had as its foundation prayer a great monarch and a great people alike should seek for a hallowing of their responsibility before the King of Kings.

The loss of HMS Thetis during sea trials on 1 June 1939 resulted in the deaths of ninety-nine souls. Only four survived. The submarine was eventually grounded on Moelfre Bay, Anglesey before an official investigation took place. She was later recommissioned as HMS Thunderbolt but sunk again after being attacked by Italian depth charges during the Second World War with the loss of her entire crew.

3rd June 1939, Liverpool Echo

98 MEN DEAD IN THE WORST SUBMARINE DISASTER

Men Believed Victims Of Vessel's Escaping Chlorine Gas

DESPERATE RESCUE WORK FAILS

Cammell Laird's Statement On What Is Thought To Have Happened

Shortly After Three This Afternoon An Official Of Cammell Lairds Told Waiting Pressmen, "We Have Now No Hope Of Saving Further Lives From The Thetis."

"We consider that the men died from the chlorine gas. The ship carried a large quantity of chlorine, which we think would escape owing to the angle at which she lay."

It was denied that there was any truth in a suggestion that they were contemplating blowing the vessel up. Now that there was no hope of saving life, the official said, they would attempt to save the vessel.

Ninety-eight men have lost their lives.

The Admiralty stated this morning that following tappings heard at 2 a.m. there was still hope at 10 a.m. to-day that some of the trapped men might be rescued alive.

Hope, however, faded as hours sped by with no news that the vessel had been brought to the surface from the position on the seabass 14 miles off the Great Orme's Head.

Then, late this afternoon an official of Cammel Lairds told the Press that hope was abandoned prior to midnight. He added, concerning the tapping said to have been heard at 2 a.m. that it was now thought to have been due to high compressors working.

TERRIFIC TASK

A terrific task faced the salvage workers who at dawn began a new attempt to raise the stern of the submarine. The first

attempt failed, one hawser parting, and although the workers then realised that the chances of rescuing the trapped men were remote they continued striving desperately to raise the submarine.

Seven additional names of men aboard announced by the Admiralty to-day, show that there were 102 men on board the Thetis when she made her fateful dive. Four of these escaped so the number of imprisoned is 98.

Throughout a night of increasing anxiety relatives and friends of the trapped men kept a sad vigil at the Birkenhead offices of Messrs Cammel Lairds, the builders of the Thetis. As time wore on womenfolk broke down under the strain and the ambulance staff was called to render first aid.

Two of the four survivors have been brought back to Merseyside. Lieutenant Woods is now in the Southern Hospital, Liverpool, suffering from nervous exhaustion and shock. Mr. Frank Shaw, a Cammel-Lairds fitter returned to his home, 31 Ivydale Road, Birkenhead, last night. He stated that he owed his life to Stoker Arnold.

Mrs. Shaw told a reporter that her husband said that the air in the submarine was foul and was getting dreadful when he left yesterday morning. He added that all the trapped men were behaving wonderfully.

The site of the Royal Court Theatre has been associated with entertainment for many years. A regular circus was held here in the early nineteenth century. This grew to become Cooke's Amphitheatre of Arts presenting a programme of opera, music, theatre and ballet. The present building opened on 17 October 1938 after its predecessor was destroyed by fire.

17th October 1938, Liverpool Echo

ALL WORK FOR THE PLAY "UP AND DOING" ARTISTS

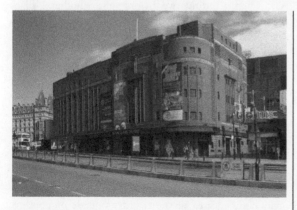

There is no idea more groundless than that which leads so many people to regard stage folk as playboys and playgirls, who are employed in glamourous surroundings for a few hours each night prior to going off for merry parties.

Anyone who feels that the life of the stage artiste - or stage technician - is a carefree existence should take course of rehearsals, particularly the long rehearsals of a big new musical production. If they are still awake at the end

of one they will realise that all plays are all work for those engaged in relieving the dullness of those "in front."

To-night, for instance, when Liverpool's splendid new Royal Court Theatre reopens with Mr. Lee Ephram's big, new musical comedy, "Under Your Hat," with that brilliant couple; Mr Jack Hulbert, and Miss Cicely Courtneidge, making their stage reappearance together after several years how many members of the audience will realise the desperately strenuous week-end which has been put in by all connected with the show.

SNAPPING INTO IT

Rehearsals began in London some weeks ago, while the contractors and their workmen feverishly to complete the theatre ready for the opening. Late on Friday night the members of the company arrived in Liverpool, and on Saturday morning the work of the final rehearsals began.

Saturday's rehearsals continued until 7 a.m. on Sunday. A few hours later, at 2 p.m., rehearsals resumed and continued until well after midnight. There was more rehearsing to-day.

What amazes the outsider present at one of these marathon rehearsals is the good temper and good spirit that prevail. At the Royal Court this week-end, although workmen were still busy putting final touches to the theatre everyone seemed to take it in their stride.

THOUROUGHNESS

Mr. Jack Hulbert (who is producing in addition to "starring") with Miss Cicely Courtneidge would be rehearsing themselves – and how thoroughly they do it – in one of the numbers which everyone will be humming shortly – "Keep It Under Your Hat" – "Together Again" or "Rise Above It."

They would have a few words with Mr. Lew Stone, the famous band leader who is the musical director. "Just quicken the temp there – pom de pom de pom," Jack Hulbert would say. Then, "I think we'll just go back to those four bars before the chorus," Miss Courtneidge might remark.

The adjustments made they would begin again, while at the back of them on stage Mr. Laurence Green, the equally tireless

stage director would be evolving order out of chaos with carpenters, electricians, and scene shifters.

All this to the accompaniment of hammers.

"I think the boys had better have a break now," Mr. Hulbert announced, while he went down to change.

The boys went, the order being repeated by calls to the men working the "lines" way up in the gallery. "Quickest cue that's been taken yet," remarked Mr. Green – "Laurrie" to most folk. There was a laugh.

After the break, Mr. Hulbert, dressed for the new number, one moment directing "the girls" from the stalls the next dashing on to the stage again to join with Miss Courtneidge in a comedy number, carried on with the good work.

Another little hitch. Words, calls, shrieks from one and another. "Black out and two spots." Then later "No. 15 Magenta," "bring your auto-blues up." "Try a 12 Pink"

So the night wore on, "Strike me pink," said the watcher to himself, "I'll leave them to it." He did. The rehearsal went on.

Merseyside was the most heavily bombed area of the country outside of London. The port was of immense importance to the British war effort and a key strategic target for Germany. May 1941 saw a renewal of the air assault on the region with a

seven-night bombardment that devastated the city. South Castle Street is seen after an attack.

3rd May 1941, Liverpool Echo

CROWDED SHELTER DRAMA IN BIG MERSEY RAID

Golden Wedding Party Tragedy; Newlyweds' Fate; Many Luck Escapes

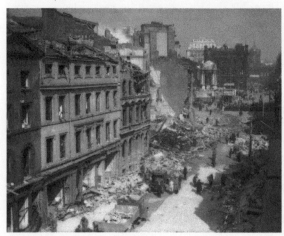

Merseyside bore the full brunt of the German attack last night, and while the Air Ministry communiqué this morning said that "casualties may be large," the Echo understands that, happily, they are not so heavy as was feared.

Five German bombers were destroyed during the night, three by night fighters – one over an aerodrome in Northern France – and two by A.A. gunfire.

The Air Ministry and Ministry of Home Security communiqué said: "Last night enemy aircraft again attacked the Merseyside area. The attack was heavy and lasted several hours.

"Early reports suggest that the number of casualties may be large and that a substantial amount of damage was done.

"An attack was also made on a town in East Anglia, where a small number casualties may be large and a considerable number of houses were damaged.

"Bombs were also dropped at other widely-separated points but these did little damage and caused very few casualties.

"Three enemy bombers were destroyed during the night, two by our fighters and one by A.A. gunfire. In addition another enemy aircraft was shot down by our night fighters over a aerodrome in Northern France making a total of four enemy destroyed during the night.

"GLAD TO BE ALIVE"

One raider crashed in a wooded area on an isolated spot and was smashed to pieces. Three of the crew were captured.

One of the airmen sat before the fireside in a country cottage, with children grouped round him, and in broken English, told them how glad he was to be alive and unhurt.

Shortly before he had been in a bomber intent on dealing out death and destruction. When his machine was shot down he was taken in custody by the police.

Observers believe a second machine was brought down by A.A. gunfire. There was a terrific flash in the sky followed by an explosion, and particles of burning material were seen.

A third enemy plane was "bagged" early to-day. According to an eye-witness it was flying very low, and appeared to be in distress before crashing. The crew of four were captured by soldiers.

HEAVIEST BARRAGE
It was Liverpool's worst raid of the year. Waves of enemy bombers were over the city continually for several hours.

Once again the fire-fighting services kept fires low, but damage was caused by a big number of high-explosive bombs.

It is believed some raiders were hit for pieces of planes were found in some areas.

As the planes came over, flying high, they were met with a barrage as heavy as anything which has yet been heard in Liverpool, and it seemed that some of them were turned from their targets.

Incendiary bombs could be seen dropping by hundreds of fire-watchers on the roofs of buildings. The great majority were dealt with before they could do any harm, but inevitably some took hold, and then came the swish and whistle of explosive bombs.

One dropped into a burning building, scattering embers in all directions, but throughout the raid all branches of the civil defence services, undaunted by the threat from the air, worked increasingly to quell fires, succour the injured, release the trapped, or help the homeless.

The peak of the bombing was in May 1941. It involved 681 Luftwaffe bombers; 2,315 high explosive bombs and 119 other explosives were dropped from the skies. The raids resulted in 2,895 known casualties and left many more homeless. The department store of Blacklers was severely damaged in the Blitz.

5th May 1941, Liverpool Echo

'ON AND VERY NEAR' WARSHIPS
An Air Ministry Announcement
NIGHT RAIDERS
More Brought Down By Fighters
L'POOL CARRIES ON

R.A.F. bombers, in another attack on the docks at Brest, last night, hit the German battle cruisers, Scharnhorst and Gneisenau.

This is revealed in an Air Ministry communique, to-day.

Seven enemy raiders are known to have been destroyed over Britain last night – six by fighters – and it is possible further additions may be made when the results of claims now being investigated are made known.

The enemy's attack in England was again concentrated on Merseyside – for the fourth night in succession – but a heavy raid was also made on Belfast.

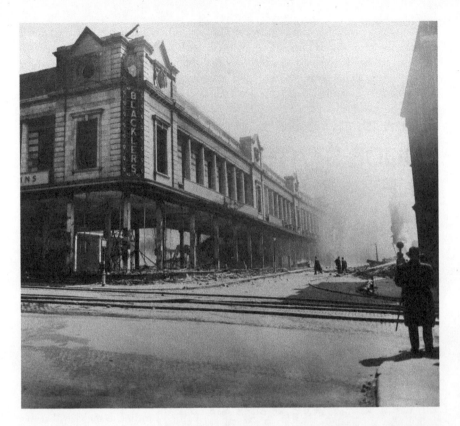

On Merseyside it is not anticipated that the loss of life in last night's raid will prove to be heavy.

A terrific barrage was set up when the first of the raiders arrived over Merseyside and night fighters was also in action.

Tremendous work had been accomplished by the A.R.P. services before people trooped into Liverpool to-day to their offices, shops and factories, grimly determined that, whatever the difficulties they would be speedily overcome.

To The Citizens

The Liverpool Civil Defence Emergency Committee, represented by the Lord Mayor (Alderman Sir Sydney Jones), Alderman A. E. Shennan, and Alderman Luke Hogan, to-day, issued the following communication:-

Liverpool has passed this, a very serious ordeal, during the last four days and nights. We should like to take this early opportunity of expressing to the citizens our great appreciation of the spirit in which they have met the crisis.

"It was only what was to be expected, but it is a great inspiration to know that Liverpool has not been behind other cities in its realisation of the importance of maintaining the steadiness of our civic life.

"We would like to express our deepest sympathy with those who have been bereaved, with those who have been dispossessed, and with all who have so heroically borne the brunt of the attack.

"We wish to assure them that no efforts are being spared to see that all the services which so vitally affect the city and the life of the people at the present time are being maintained to the fullest possible extent."

The murders of cinema manager Leonard Thomas and his assistant Bernard Catterall shocked readers in March 1949. Two men, Charles Connolly and George Kelly were convicted in a controversial trial which saw Kelly hang, and Connolly imprisoned for ten years. After a long campaign, the Court of Criminal Appeal judged their conviction to be unsafe and quashed their sentences years later in 2003.

21 March 1949, Liverpool Echo

POLICE STATEMENT ON CINEMA SHOOTING

Weapon Used May Be A Foreign Type Of Automatic

Hundreds Of People Interviewed

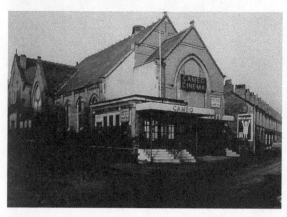

Liverpool C.I.D. officers, searching for the masked gunman who on Saturday night shot and killed the manager and the assistant manager of the Cameo Cinema, Webster Road, Wavertree, Liverpool, have investigated the possibility of a link between the two shootings and threats to local cinema managers from a gang of youths.

In January, a cinema manager from another part of the city, who was acting as manager of the Cameo Cinema, was attacked by a youth, and had to receive treatment in hospital.

TO MANAGERS

The man had previously been warned of the activities of this gang and had been told not to let them into the cinema.

Mr. Leonard Thomas the murdered manager of the Cameo Cinema, had been threatened by the gang, and threats had been made to the managers of three other cinemas in the locality.

Although these matters are of necessity being investigated by the police, expert opinion does not incline to the view that the gunman was a youth.

NO REAL CLUE

Chief Superintendent Smith said there was nothing left behind in the office which provided any real clue.

So far they had not come across any people in the district who appeared to be missing, although it was made difficult because it was an area with a "floating" population.

He said that they no longer believed at all in the "gang" theory that the crime had been committed by a gang of youths, who have been threatening cinema managers.

CORDON ROUND CITY

Theories that the killer has got away from the Liverpool area still appear to be discounted. The cordon around Liverpool was maintained this morning with the assistance of the dock police, railway police, every available uniformed man and the patrol car staffs.

In the neighbourhood of the Cameo Cinema, which is expected to reopen this afternoon, there was far less activity, although detectives were still interviewing householders in the streets near to the cinema, and a number of housewives stood at the doors obviously talking over the tragedy.

Chief Superintendent Smith, at his temporary headquarters at Lawrence Road Police Station, said he had nothing further to report at the moment.

MASKED MAN

To obtain a clear-cut description has been difficult as the gunman had a hat pulled down over his face and was masked up to the eyes. His description by the police is:-

"Between 20 and 30 years of age, about 5ft. 8ins. in height, medium to broad built, rather full faced, and possibly with dark hair. Believed to be dressed in a brown double-breasted overcoat with belt all round, black shoes and trilby hat."

Nearly 100 plain clothes officers, under Chief Superintendent T. A. Smith, head of the Liverpool C.I.D., have now been on practically continuous duty for 36 hours in a sustained effort to track down the gunman, who used an automatic weapon and may still have ammunition for this.

House-to-house inquiries in the locality of the cinema are being continued, and the police appeal to anyone who thinks he saw the man dashing away from the cinema to come forward. Some people have already been interviewed.

FINGERPRINTS

Fingerprint experts are also busy to-day. Numerous prints were found in the manager's office at the cinema where the crime was committed, and as some of these may belong to members of the staff they require eliminating.

Search for the weapon, believed to be of Continental type, firing 38 bullets, is also continuing. The gun-man may have disposed of it during his getaway.

The man followed the cashier, Mrs. Nellie Jackson, of Pengwern Grove, Liverpool, when she took the day's takings from the pay-box to the manager's office, while the audience were watching the film "Bond Street," in which there is a shooting incident.

The police believe that the gunman watched the film from a seat in the back stalls, and after the cashier had come up the cinema aisle he allowed her time to leave the manager's office before he left his seat. Tying the black silk scarf over the lower half of his face and pulling the brim of his hat low, he went to the foot of the stairs and cut the telephone connection.

STRUGGLE IN THE OFFICE

In the office, Mr. Thomas and Mr. Caterall, the assistant manager, were counting the day's takings when the gunman walked in. They immediately jumped up, and one of them went to close the door to shut off the intruder's escape.

There was then a desperate struggle, during which the man, becoming panic stricken, drew his gun and began to fire wildly, it is surmised.

Mr. Thomas fell fatally wounded with a bullet in the chest. Mr. Caterall, although wounded with a bullet through his right palm, fought on.

FOUR WOUNDS

But the man shot him again in the right side of the chest, and as he fell

fired a third and what it believed to be fatal shot into his back. He had four wounds, one an exit wound.

During the struggle, papers and money were strewn all over the room but the intruder got nothing.

Liverpool enjoyed the Festival of Britain celebrations in 1951 with decorations and adornments springing up across the city.

18th July 1951, Liverpool Echo

LIVERPOOL GETS INTO THE HOLIDAY MOOD

Flags and Flowers

City Beautiful

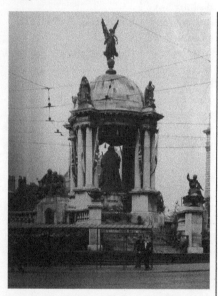

The decoration of Liverpool in readiness for the Festival is nearing completion and those who were disposed to scoff when the first bunting and white-painted poles went up are now converted to the idea of a little beautification of the city, however superficial.

This outburst of colour and gaiety is already inducing a more cheerful spirit.

People are saying for instance, that those hanging baskets of flowers on tram standards and elsewhere ought to become a permanent feature, and the flower beds in the big blitz hollow at the upper end of Lord Street are, of course, something for which many people have long been agitating.

The City Council voted a total of £20,000 for Festival decorations and illuminations, and the scheme was entrusted to the city architect's and lighting departments. In the belief that the variety is the spice of decoration, the designers have used colours to the most attractive effect.

Castle Street Gold.

The most striking appearance is that of Castle Street with its 10ft flagpoles carrying gold-edged banners strung with tassels and surmounted by Liverpool's festive symbol. These brilliant decorations will form a fitting frame for the military ceremonies before the Town Hall entrance and for the great processions that will set out from there.

Radiating ropes of bunting from the top of the Wellington Monument and bright

drapery and yard-long tassels adorning the great block of blackened buildings in William Brown Street, stretching from the College of Technology to the be-flagged Walker Art Gallery, relieve the normal gloom of the masonry.

The scene here will be made brighter still by flo- ral decorations – window boxes and flowers and shrubs leading up the steps.

Across the way the sooty mass of St. George's Hall is having great panels of the red material hung between the columns and the St. John's Gardens façade forms the background for a fine array of coloured poles.

Bold Street is crossed by large banners emblazoned with the city's coat of arms, and all along the route of the processions, including Church Street, Ranelagh Street, Lime Street and Dale Street the kerbs are lined with white standards already material of with banners ready to be unfurled.

A destructive blaze raged through the magnificent Croxteth Hall on 28 June 1952. The property had been the seat of the Earls of Sefton since the sixteenth century, but when the last Earl died without an heir in 1972, the house passed to Liverpool City Council. The damaged wing of the property was finally restored sixty years later.

30th June 1952, Liverpool Echo

SALVAGE WORK AT CROXTETH HALL TO-DAY CLEANING UP AFTER THE BLAZE

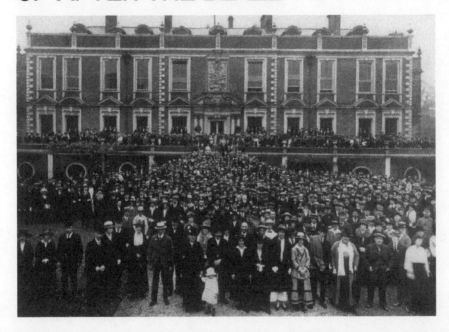

Liverpool Salvage Corps still had a crew working to-day on the Queen Anne wing of Croxteth Hall, home of the Earl and Countess of Sefton which was severely damaged by fire on Saturday night.

They were removing furniture they had protected earlier by sheeting, getting water away and cleaning up generally.

The furniture and other valuables were put in various parts of the hall away from the wing.

TREASURES SAVED

The fire was discovered shortly after 5.30 p.m. on Saturday. It started in one of the second floor bedrooms, not in use, and spread to servants' sleeping quarters destroyed. Some servants' clothing was lost.

The drawing room in the centre of the wing, which was once the main entrance to the Hall, was practically burnt out. The ornamental ceiling collapsed. The smoke room and library on the main floor were damaged by water.

Books from the library were recovered by a chain of staff and the personnel, valuable pictures including a Gainsborough were retrieved: and furniture and carpets saved from major damage.

When the alarm had been given by the French chef, M. Raymond Lamperieur. Lady Sefton ran from the paddock half a mile away, and for two hours worked with the staff and fire personnel.

Lord Derby (Lord Leiutenant of Lancashire) came from nearby Knowsley Hall to help and Earl Sefton, who was at a Boy Scouts' rally at Wigan, raced back by car. He praised the work of the staff and the fire fighters.

Often the staff had to work with wet handkerchiefs tied round their faces to protect them from the smoke.

The coronation of Queen Elizabeth II created plenty of newsprint in June 1953 as the Commonwealth celebrated the ascension of the new monarch.

2nd June 1953, Liverpool Echo

THE QUEEN HAD NEVER LOOKED MORE LOVELY

Radiant Smiles For Cheering Thousands On Route To Her Coronation

In a scene of fairy tale splendour, the Queen set off from her Palace for her crowning at four minutes before the clock struck half-past ten. There was as smile of great happiness on her face.

She left the grand entrance in the Inner Quadrangle from the same place from which she had set off for her marriage on an autumn day over five years ago.

Slowly in her lovely rich gown, she walked along the marble-pillared corridor at the top of the grand hall.

The loveliness of great vases of many coloured flowers filled the white and gold hall with their beauty and their perfume.

Members of the Yeomen of the Guard stood on duty across the floor of the hall from the steps to the doorway, their

eight-foot partisans gleaming bright. The rich colours of the uniform and robes – blue and scarlet, and the white of ermine – made a background of splendour.

Pages and footmen wore their state dress – some in black and gold and some in scarlet and gold – which has not been seen at the Palace for 15 years.

The Sovereign's Escort of the Household Cavalry – a glittering cavalcade of horsemen each man on a black charger massed in the Inner Quadrangle. The last procession set out, and as these final carriages drew away, the Queen came along the corridor. She has never looked more lovely than on this glorious day.

From the top of the steps of the hall, the Queen watched the great ornate State coach, drawn by eight grey horses rumble up to the grand entrance under the glass portico.

Four footmen carried her long train as she stood talking to members of her household and waiting for the moment when she was to set out.

The Queen was early. She came down to the hall eleven minutes before the coach was due to leave.

She stood for some time talking with the Duke of Beaufort. Master of the Horse, with the Lord Chamberlain, who carried his long white wand of office, and with the Master of the Household.

SEEMED NERVOUS

To those who knew her well, she seemed, they said, a little nervous.

The minutes ticked away, then the Queen, with a final smile to her staff, her head erect, walked to the grand entrance. Pages in their State dress bore her robes. Once she was seated in the State coach, footmen arranged the folds of her robes.

The Duke of Edinburgh in the uniform of an Admiral of the Fleet, took his seat on the Queen's left.

The Royal couple then had some minutes to wait before the time for the start. The interior lighting of the coach sparkled on the diadem which the Queen wore.

Finally, the hands of the clock moved to 10.26 – a quiet order was given and the State coach moved off to take the Queen to her crowning.

So at last it came from the Palace the fairy-tale State coach, like the sun itself breaking through the clouds and shedding its life giving warmth on thousands and scores of thousands.

There was just the slightest possible hush, as if this is indeed were a fairy tale after all the weariness and waiting.

The Overhead Railway closed in 1956 after the costs of maintaining the line became too high. An original carriage has been preserved and can be seen on display at the Museum of Liverpool.

31th December 1956, Liverpool Echo

FIRST DAY WITHOUT OVERHEAD LINE SHUTS AFTER 63 YEARS

Small Staff Kept On

STILL HOPE

By George Eglin

This is a sad day on Merseyside. For the first time in 63 years, no train was running on the Liverpool Overhead Railway. The line closed at 10.30 p.m. last night, when the two last trains came to a halt in Dingle and Seaforth stations.

Even during the worst periods of the blitz when sections of the line were destroyed, some sort of service was kept going. But to-day after two years of frustration and discussion, the Overhead tracks are deserted, and to thousands Liverpool did not seem the same.

But although the line is closed and forlorn, there is still hope that it will return to service as a modernised railway. Replies are still coming in to the Town Clerk of Liverpool from organisations who have been asked to nominate a representative to serve on a committee to consider how the Overhead can be reopened. An early meeting of the committee is planned.

UNDER COVER

To-day Mr. H. M. Rostron, general manager of the overhead Company, said nothing would be done for the time being that would prevent the line being reopened.

"This is a sad morning indeed," said Mr. Rostron. "We are stabling all the trains under cover with their doors locked. They will be divided between Dingle and Seaforth, and will be ready for driving off to the workshops for overhauling and rebuilding if some way of continuing the line can be found.

"We shall keep a small staff of watchmen and caretakers to take care of the structure and buildings, and nothing at all will be done that might hamper the rebirth of the Overhead.

STAFF THANKED

This morning Mr. Rostron issued a special message of thanks to his old staff. "They deserve the thanks of every passenger," he

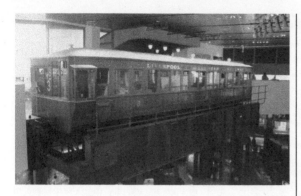

said. "If it had not been for the devoted work of | the staff under great difficulties, it would have been | impossible to keep the line going so long, I am grateful to them all and especially to the women who have done men's work to help us to keep going."

Mr. Rostron's present contract with the Overhead Company expires in March. If he does finish work then, he plans to set up his own practice in Liverpool as a consulting engineer.

In 1957 Liverpool celebrated its 750th birthday. The city hosted a variety of events to commemorate the occasion ranging from maritime exhibitions to classical concerts.

17th June 1957, Liverpool Echo

LIVERPOOL PRIDE AS CIT

SUNSHINE GRACES THE CHARTER SEND-OFF

Lord Mayor's Busiest Day: Six Exhibitions Opened

KINGSMEN ON GUARD

Industry Shows its Wares In Five Tented Pavillions

In brilliant sunshine, the Lord Mayor of Liverpool (Alderman Frank H.Cain) to-day led the citizens in celebration of the 750th birthday of the city – the anniversary of the granting of the charter by King John.

There was pride in the heart of Liverpool as it put itself on show in a way that surprised visitors with the scope of its modern achievements – and even impressed many of the people who live in the city.

The Lord Mayor started his busiest day since he took office by opening four exhibitions, and inspecting a ceremonial

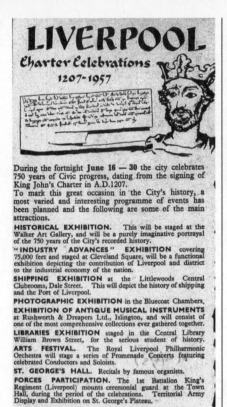

During the fortnight **June 16 — 30** the city celebrates 750 years of Civic progress, dating from the signing of King John's Charter in A.D.1207.
To mark this great occasion in the City's history, a most varied and interesting programme of events has been planned and the following are some of the main attractions.
HISTORICAL EXHIBITION. This will be staged at the Walker Art Gallery, and will be a purely imaginative portrayal of the 750 years of the City's recorded history.
"INDUSTRY ADVANCES" EXHIBITION covering 75,000 feet and staged at Cleveland Square, will be a functional exhibition depicting the contribution of Liverpool and district to the industrial economy of the nation.
SHIPPING EXHIBITION at the Littlewoods Central Clubrooms, Dale Street. This will depict the history of shipping and the Port of Liverpool.
PHOTOGRAPHIC EXHIBITION in the Bluecoat Chambers.
EXHIBITION OF ANTIQUE MUSICAL INSTRUMENTS at Rushworth & Dreapers Ltd., Islington, and will consist of one of the most comprehensive collections ever gathered together.
LIBRARIES EXHIBITION staged in the Central Library William Brown Street, for the serious student of history.
ARTS FESTIVAL. The Royal Liverpool Philharmonic Orchestra will stage a series of Promenade Concerts featuring celebrated Conductors and Soloists.
ST. GEORGE'S HALL. Recitals by famous organists.
FORCES PARTICIPATION. The 1st Battalion King's Regiment (Liverpool) mounts ceremonial guard at the Town Hall, during the period of the celebrations. Territorial Army Display and Exhibition on St. George's Plateau.

> **ROYAL VISIT**
> Her Majesty Queen Elizabeth the Queen Mother will mark the Charter Celebrations and honour the City by paying an all day visit on Tuesday, 25th June.

TOWN CLERK
INFORMATION OFFICE
LIVERPOOL CORPORATION
DALE STREET :: LIVERPOOL

military guard outside the Town Hall and a Merchant Navy guard of honour during the morning. This afternoon, he opened two other exhibitions and to-night he will declare open the restored great organ in St. George's Hall.

When he opened the Maritime Exhibition in Littlewoods clubrooms in Dale Street – one of the four he opened during the morning – the Lord Mayor pledged the city's support for a permanent shipping museum.

MERSEYSIDE PRODUCTS DISPLAYED

"It is a great city pity that the people of Liverpool cannot see their own permanent shipping display," he said. "A seaport like this should have a maritime museum. The City Council have the idea in mind and it will not be neglected when it is possible to overcome the problems of money and a suitable building."

Earlier, the Lord Mayor rode along the bannered length of Castle Street to open the "Industry Advances" exhibition on a 75,000 square foot site in Cleveland Square. In five tented pavilions scores of Merseyside firms are displaying the products and the methods of industry in the area.

The opening ceremony took place against a glittering facade of scarlet and white, topped with stylised Liver birds. The exhibition has been designed by Mr. Kenneth Hughes, an architect in the City Architect's Department.

Bearded Mr. Hughes who lives at Wallasey and was an R.A.M.C. paratrooper during the war, has also designed the decorative displays in Castle Street and on the Town Hall.

A procession of trams paraded through the streets on 14 September 1957 to observe the closure of the city's tram routes. They left the Pier Head via the city centre to travel to the terminus near Bowring Park. Trams had been a regular sight for locals since their introduction in 1897.

13th September 1957

LAST CITY TRAM WILL LEAVE TO MUSIC

Sixty Years of History

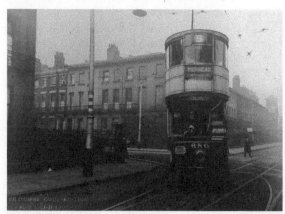

The clanking of the city's last 13 trams from the Pier Head to Bowring Park and back to the Edge Lane Depot to-morrow night will mark the end of an association between the Liverpool Corporation and tramways which has extended over 60 years and 14 days.

The last run will be on 662 and 40 routes, the only route to be left in operation since the Kirby routes were converted last November.

The 13 trams will leave the Pier Head at intervals of a few minutes each, the first leaving at 5.30 p.m. and the last, Tram No. 293, specially painted cream at 5.55 p.m. The last to leave is expected to finish up at Edge Lane at about 6.45 p.m. Each will carry 70 passengers all of whom will have been allotted tickets as the result of personal application. The very last tram will carry the Lord Mayor, members of the Passenger Transport Committee and senior officials of the Corporation.

Old Style Tickets

All this week travellers on the trams have been issued with the old-style paste-board tickets bearing the name of each fare stage, instead of the numbered alimsles which have been taken their place in recent years. To punch the hole cancelling each ticket machines had to be borrowed from the London Transport Department.

Before the trams leave the Pier Head a band will play suitable music and a band will also play at the Edge Lane Depot as the last one rumbles in. The very last to leave will travel very slowly through the city escorted by police on motor-cycles.

Among the passengers will be five former employees of the department, four of whom are over 80. Representing the shed staff will be 79-years-old Mr. H. Cundall, Flat D, 10 Pankhurst Road, Liverpool, one time conductor on the horse trams which preceded the electrification programme and later maintenance foreman at the Dingle Depot. The traffic staff will be represented by Mr. Hugh Thomas Howell, aged 83, of 23 Rufford Road, Bootle conductor on the first horse tram to leave the Bridge Road terminus and also on the first electric tram to travel along Stanley Road.

FIRST LINESMAN

Eighty-óne-years-old Mr Frederick William Whitenorn will represent the inspectors. Mr. Frederick George Nell aged 80 of 30 Alyanley Road, the first overhead linesman in the department, will respresent the overhead lines maintenance staff, and 83-years-old Mr. Richard Gobson Ballam of 93 Larkfield Road, Liverpool who joined the department as a 12-years-old boy in 1886, will represent the traffic side. Also present will be Alderman Stanley Part, chairman of the Passenger Transport Committee since 1955, and Mr. W. M. Hall, general manager since 1943.

It was on September 1 1897 that the Liverpool Corporation first entered the transport business as operators, buying, 267 horse trams and 100 horse buses from the old Liverpool United Tramways and Omnibus Co. Ltd who had been existence since 1879.

It took the Corporation just three and a half years to electrify the whole system double the number of passengers and reduce the original fares by 30 per cent.

Gradually the tram tracks reached further and further out into the suburbs. All the time experiments were taking place. One type of tram, withdrawn in 1929 after an experimental period, had 83 seats on two decks. At first too, trailers were used, but they were soon discontinued.

REACHED PEAK

By 1939 the tram fleet had reached its peak with 184 vehicles.

In 1939 the undertaking owned four times as many trams as buses, but the bus fleet, born in 1911, was being gradually expanded to meet the needs of outlying areas.

Now the Passenger Transport Department has 1,265 buses serving an area of 77 square miles. Last year they carried 359 million passengers a total of 38,436,076 miles.

Tragedy struck the city on 22 June 1960. On that fateful day eleven people were killed as a blazing fire tore through the Liverpool branch of the Henderson's department store, Church Street.

22nd June 1960, Liverpool Echo

OIL THREAT AS FIRE HAVOC

MAN FALLS FROM TOP FLOOR: GIRLS ARE RESCUED

One Of Staff Is Reported Missing

A member of the staff who stayed in the building to fight the blaze with extinguishers was reported missing when the fire had seriously damaged William Henderson's store in Church Street, Liverpool, this afternoon.

The missing man is maintenance manager Mr. Ron Terry, who had not been

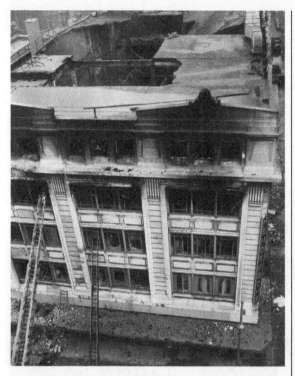

Street. These were quickly extinguished.

New Shop Threat

Flames threatened the new premises of Timothy White's at the corner of Whitechapel. Then opening of this shop due tomorrow, has been postponed.

All premises in the area were evacuated when it was reported that there were 10,000 gallons of oil in the basement of the blazing building.

Fifteen pumps with over 100 firemen were rushed to the five-storey building from all over the city while reinforcement were rushed in from other areas.

Before the firemen gained control explosions rocked the building. Falling masonry smashed through glass canopies at ground floor level.

Mr. J. W. T. Smith (Chief Constable of Liverpool) who attended, told the Echo: "Apart from the blitz this is the worst store fire in Liverpool in my experience. I cannot recollect anything like it happening during the day."

seen since the fire was discovered. The administration building was searched but Mr. Terry was missing. He was last seen trying to fight the blaze.

Another man, who was injured when he plunged from the top storey shortly after the fire started at 2.30 died later in hospital.

The man who died was later identified as Colin Murphy aged 34, of Turrett Road, Wallasey.

Seven other people were injured – two seriously – and are detained in the Royal Infirmary an Northern Hospital.

Four people – two men and two girls – were rescued from the top of the building by firemen using turn-table ladders.

At the height of the blaze flames, spread to the Tatler cinema in Church Street and Smith's Piano Store in Williamson

The premier of The Beatles film, A Hard Day's Night, took place on 10 July 1964 at the Liverpool Odeon. The screening saw crowds of screaming fans turn out to catch a glimpse of the Fab Four as they arrived back in their hometown.

10th July 1964, Liverpool Echo

BEATLES' FILM IS A BOX OFFICE SELL-OUT

Fans Line-Up Early At Town Hall And Airport

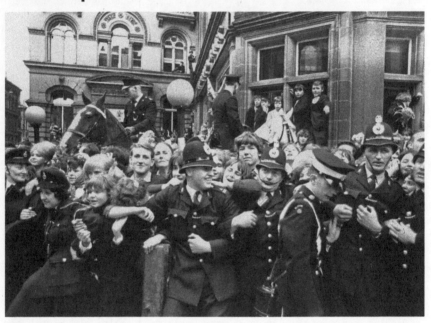

The charity premiere to-night of The Beatles' film "A Hard Day's Night" is a sell-out.

A spokesman at the Odeon Cinema said this morning that the box office had been inundated with last minute requests for tickets.

"All the seats were sold early yesterday and we have just had to turn people away," he said.

Charities benefiting from the premiere are the Liverpool Boys' Association, who will get 75 per cent of the taking, and the Gordonstoun Scholarship Foundation which will receive the remaining quarter.

SAFETY MEASURES

Just across the road from the Town Hall this morning workmen were erecting hard-board sheets over the windows of Martin's Bank building at the corner of Water Street.

"The idea is to keep the crowd from standing on the window ledges," said Mr. Jones, the joiner who was erecting the sheets. "You know they might topple backwards and fall right through the window.

"We are also doing it to save the marvellous carving around the windows – we don't want it chipped," said Mr. Percy Brugnoli.

TEA RELAYS

One of the first teenagers to arrive at the Town Hall was 15-years-old Hazel Kellett, of 108 Moss Lane,

Litherland. She was taking no chances with the weather and was well wrapped in a duffle coat, slacks, and sweater.

"I have lots of sandwiches for my dinner and my friends and I will be going to the Pier Head for cups of tea in relay," Hazel said.

"We have a fourteen-foot long banner with "Welcome home lads" painted on it. We did want to put it up on the balcony of the Town Hall, but they wouldn't let us," said Hazel.

FERRY TRIP

Another early arrival was Patsy Feeney, aged 14, of 12 Field Way, Huyton, who arrived at the Town Hall well before 9 a.m. and to pass away the time she with two of her friends. Lynn McKeown, aged 14, and Susan Oaks, aged 14, both from Huyton, took a trip to Birkenhead by ferry.

Many others arrived later from as far away as Crewe, Bolton and Wigan. Three teenage machinists, Barbara Ashurst, aged 17, of 16 Ridgeway, Blackrod near Wigan and Phyllis Haddock, aged 15, of 7 Longfield Street, New Springs, have taken a fortnight's holiday so that they could see their idols.

Said Barbara: "We unfortunately don't have any tickets for the film, so we thought the next best

thing to do was come and watch them arrive at the Town Hall.

And Moher Waited Too

Fourteen-year-old Jennifer Latham and her mother Mrs. Doris Latham were also outside the Town Hall.

"We live in Crewe," said Jennifer, "and were in Liverpool to do some shopping but I managed to persuade mother to stand in the queue here. I don't think we'll get any shopping done now."

Another fan, 15-years-old Maureen Jones, of 34 Avondale Street, Bolton, had taken time off from work as a nylon examiner in a stocking factory. "I was up at 6.30 this morning and arranged to meet a friend at 9 o'clock," she said, "but the friend let me down and I had to come here on my own. I was determined not to miss them."

10 rush barriers were erected on the right hand side of William Brown Street by Corporation workmen as early as 11 a.m.

The Beatles will not now arrive in the Viscount aircraft City of Liverpool.

With Two Viscounts out of service this morning, and taking into account extra accommodation required as a result of the London Airport strike to-day. British

Eagle announced that the Beatles would be travelling in a Brittania.

The first-class compartment - 16 seats - will accommodate the Beatle's party.

Flight take-off was to be at 4.15 p.m., with touchdown at Liverpool, as planned. The Britannia will carry about 100 passengers, and after calling at Liverpool will continue to Glasgow.

60 Fans At The Airport

By lunchtime only 60 young Beatle fans - nearly all of them school girls - had gathered at Liverpool Airport to wait for the group's arrival.

Extra police were on duty but they had little work to do as the fans basked in the sunshine on the upper balcony of the terminal buildings. Many of the girls said they had played truant from school in order to get a good spot on the balcony.

Said a police officer: "They've all been very orderly - no trouble at all."

Ann Cassidy, aged 13, of 21 St. Bernards Drive, Bootle, said: "I've taken the day off school. I got up at 6.30 to get here - I was so excited I couldn't eat my breakfast.

Conlon, aged 14, of Netherton; "I want to see the film but I can't afford to go to-night as, it costs too much."

BANNERS READY

By 3 p.m. about 200 fans had arrived at the airport and were lining the outside balcony.

Banners ready to welcome the group were tied over the balcony rails. One made by 17-years-old Julie Rimmer, of 2 Beechall Close, Gateacre, and 17-years-old Jennifer Birch, of 25 Marotn Green, Spejke, proclaimed in bright red letters "Welcome Home" with the symbol of a Liver bird at the end.

FIRST-AID

All available personnel from the St. John Ambulance Brigade and the British Red Cross Society were on hand in Liverpool to-day ready to cope with any casualties which might occur during the Beatles' visit.

Ambulances and crews were stationed at Liverpool Airport, Liverpool Town Hall, and Pudsey Street, near the Odeon Cinema. There were reserve crews and ambulances too at St. George's Hall.

"We have got all available ambulance and nursing personnel from number five area – which covers all Merseyside – on duty," said a St. John Ambulance Brigade spokesman.

They were to be on duty in Liverpool from 3 p.m. until after midnight.

"We are fully prepared for anything that might occur," the spokesman added.

A new route for Merseyside arrived on 24 June 1971 when the Queen officially declared the Kingsway Tunnel open. It was constructed to help the Queensway Tunnel cope with the rise in post war traffic. Driver Danny Williams and shift boss Bill Joblin are seen making the final breakthrough during its construction.

24th June 1971, Liverpool Echo

HER MAJESTY HONOURS THE MEMORY OF HER FATHER

By Don Mckinlay

It's the – kingway. That is the name of the second Mersey Tunnel, the name chosen by the Queen at this afternoon's historic opening.

'My grandfather named the first Mersey Tunnel Queensway in honour of Queen Mary. So in honour of my father it is with the greatest pleasure that I declare the second Mersey Tunnel open and name it Kingsway,' said the Queen.

And the name – Liverpool's best kept secret – pleased all. A big burst of cheering followed from the gathering as the long blue curtains at the tunnel entrance released by the button press of the Queen fell aside.

And there above the entrance, carved in beautiful Westmorland green stone was the big 31ft long name, each letter covered in gold leaf.

The opening was a colourful yet a simple ceremony watched by a 6,000 crowd, including 200 schoolchildren, a cross section of city life.

And for the great occasion Liverpool put on its best face with a warm sun shining from a blue, almost cloud free sky.

In her speech to the assembly the Queen said: 'I am delighted to be on Merseyside to-day, both in

But since 1934 traffic has grown enormously. Now one third of a million vehicles now pass through the tunnel every week.

The new tunnel is now an essential part of the modernisation of the road network. It will give more room for cross-river traffic and it will make a valuable contribution to the life on the communities on both sides of the Mersey.

The construction of a tunnel this size is always a notable feat of engineering. This one was not accomplished without conquering severe obstacles. The most modern methods have been used including the use of a mechanical mole in the excavation.

A second tube is already being built alongside. All this is a great achievement and Merseyside can be justly proud.

I warmly congratulate the Mersey Tunnel Committee, the architects, engineers and contractors and everyone else concerned in this remarkable venture.

Liverpool and very shortly in Wallasey. The deep water of the River Mersey has been the foundation of Merseyside's growth. It has attracted shipping, encouraged trade and helped to give Merseyside its own life and personality.

Highway to the world
'It has been a highway to the world. But the river has also been a barrier. There has always been the problem of carrying people and goods across it.

First there were ferries. These were later supplemented by the rail tunnel. Then in 1934 my grandparents, King George V and Queen Mary, opened the first road tunnel under the Mersey and the effect of the tunnel was dramatic.

Knowsley Safari Park opened on 1 July 1971. The road through the park was originally 3.5 miles long and took visitors past lions, cheetahs, monkeys, giraffes, zebra, elephants and antelope. Due to overwhelming popularity an additional 1.5 miles was added in 1973, along with camels, buffalo, white rhino and tigers.

9th June 1971

MAKE SURE THE CAR IS SOUND WHEN YOU GO ON SAFARI AT KNOWSLEY

A warning to motorists visiting the new Safari Park, at Knowsley, particularly at week-ends, to make sure that they have plenty of petrol and that the vehicles was mechanically sound, was given to-day by the Automobile Association.

Superintendent Tom Challice, head of the A.A's North West Patrol Force told me that last Sunday they had dealt with 207 breakdowns in the park, the majority due to cars running of the petrol, engines over-heating and clutch and fan belt failures.

"On a busy day such as last Sunday, in a continuous crawl of traffic, the five mile run through the park is equal to a journey of 30 miles or more and this kind of stop-start motoring plays havoc with petrol consumption, cooling systems and clutches.

"Any car not in good condition and not previously checked to deal with this type of stress is likely to be in trouble."

Superintendent Chalice points out that the A.A.'s patrols are not allowed to attend to breakdowns inside the lion and cheetah reserves except in cases of extreme emergency and then only under the protection of an armed warden.

To be on the safe side a small car should have two galons of petrol in the tank entering the park and a large car not less than five gallons.

The County of Merseyside was established on 1 April 1974 along with Merseyside County Council, but this was later abolished. Today there are five unitary authorities within the County of Merseyside: Liverpool, Knowsley, Sefton, St. Helens and Wirral. There are still some County bodies such as Merseyside Police and Merseyside Fire and Rescue, but most local authority services are undertaken by the five unitary authorities.

1st April 1974, Liverpool Echo

ALL CHANGE ON THE LOCAL SCENE

It was all-change to-day for local government. On Merseyside, replacing more than twenty-five councils, a new areas, from Southport down to Wirral, Bootle over to St. Helens, are now in a new postal district called Merseyside.

Also new to-day—Merseyside county police force, county fire brigade and county public transport, all part of the country council. New bodies, now apart from local government, are a North West water authority and a new health authority.

Most of the large new councils remain in existing town halls, but county council will shortly move to a new office block in Old Hall Street.

Bill Shankly shocked fans when he announced his retirement in 1974, after fifteen years at Liverpool F.C. He is still regarded as one of the club's greatest ever managers.

12th July 1974, Liverpool Echo

SOCCER BOMBSHELL – SHANKLY RETIRES

by Alex Goodman and Alf Green.

Liverpool F.C. manager, Bill Shankly, in charge at Anfield for 15 years, to-day stunned the soccer world by announcing his retirement.

Mr. Shankly, who has made Liverpool into one of the top clubs in the world and led them to countless successes, told of his shock decision at a packed Press conference at Anfield.

Mr. Shankly, aged 60, said: "This decision has been the most difficult thing in the world and when I went to the chairman to tell him it was like walking to the electric chair."

He added: "This has not been a decision that has been taken quickly. It has been on my mind for the last 12 months, but my wife and I both feel that we want a rest from the game which we have served for 43 years so that we can charge up our batteries again."

The club chairman, Mr John Smith, said the board had to announce with "great regret" that Mr. Shankly wanted to retire.

He said: "It is with extreme reluctance that we accept this and we want to place on record our great appreciation of the magnificent job he has done for us."

Mr. Smith added: "He has agreed give every assistance to the club for as long as necessary."

Mr. Shankly's decision is the biggest sensation in soccer since Sir Alf Ramsey was sacked as England team manager.

The King of Kop was in sparkling form as he held court for the last time in the main lounge at Anfield, flanked by seven directors.

Asked if he thought he could survive without football. Mr Shankly replied: "I can't really answer that question - yet. I'll have to wait and see. Some people say that I will be bored. I'll have to risk that.

"This is a big game. There are many things one can do."

Asked if this implied that he might turn to coaching, scouting or even managing elsewhere. Mr. Shankly said: "I'm leaving the Liverpool club for retirement. There is absolutely no animosity between the directors and myself. There is all the goodwill in the world.

"My intentions have been kept secret for five weeks during which the directors have been bartering and putting all sorts of propositions that even Paul Getty might have been tempted to take."

Asked about the future, Mr. Smith said the board would be giving every consideration to the future at a meeting to be held shortly. "We realise the size of the task ahead," he added.

Mr. Shankly said that he and his wife intended to continue to live in Liverpool.

Asked where he would be on Monday morning, Mr. Shankly replied: "Here at Anfield. I will be giving them every help and assistance until a successor is appointed."

Red Rum made history at the 1977 Grand National at Aintree by winning the race for the third time. When he died in 1995, the horse's remains were buried at the Grand National finishing post.

4th April 1977, Liverpool Echo

WONDER HORSE RED RUM STARTED THE DAY WITH A RUB-DOWN AND A STROLL ROUND THE FAMILIAR BACK STREETS OF BIRKDALE.

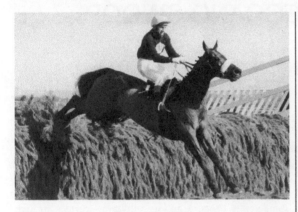

For the hero of Aintree, it was the start of a well-deserved Easter break. It will be another week before stable lad Billy Beardwood of Norris Green, Liverpool, takes him for a gallop on Southport sands.

But for everyone else at 'Ginger' McCain's training stables, in Upper Aughton Road, life was back to normal after Saturday's historic Grand National win and a weekend of champagne celebrations.

At Southport Town Hall there were moves to pay a special tribute to the triple National winner, who has made the Merseyside resort a household name.

Councillor Charles Currall, is to lay on a civic reception for Rummy's owner, 89-years-old Mr. Noel Le Mare, and trainer. It is hoped Red Rum will do a lap of honour in Lord Street to mark the occasion.

Gentleman rider, Mr. John Carden, nick-named The Joker of Aintree, remained ill but comfortable at Walton Hospital today after he smashed his ribs and punctured a lung when his mount Huperade fell as the first fence.

It was the greatest Grand National ever for racecourse managers, Ladbroke's, who though losing £1,500,000 in bets, managed to break even on the event.

They are looking for an even on the event.

They are looking for an even bigger, attendance next year.

"It's frightening to think of just how many people we will get," said Ladbroke's special promotions manager, Mr. Mike Dillion.

"Next year it could be 75,000 and, who knows, we may even top the ton in time. The National is once again something that Merseyside and Liverpool can be proud of. It is part of our national heritage.

"The 51,000 crowd was out of this world and they had the experience of seeing a horse become immortal," said Mr. Dillon.

In fact, the only people Ladbroke's didn't praise were the handful of protes- tors who planned to wreck the start of the big race.

But the group, supporters of a campaign to free Alan McAleny, the Huyton man they believe was wrongly convicted for armed robbery, were soon dispersed by police.

In 1901 Liverpudlian Frank Hornby invented Meccano, a construction toy now known across the globe. Production remained in the UK until 1979 when a bid from a French manufacturer was accepted. The move was not welcomed by British workers who made headlines after occupying the Binns Road factory in March 1980, but to no avail.

11th March 1980, Liverpool Echo

BAILIFFS MECCANO SWOOP

By Tony Martin

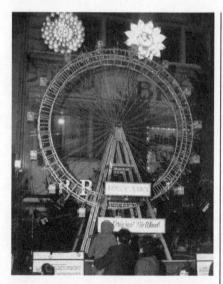

A PRE-DAWN swoop by High Court bailiffs gained Meccano management access to their Liverpool factory today for the first time in three months.

The bailiffs turned up at the occupied toy factory shortly after five o'clock this morning and smashed their way through a locked door.

Caught unawares, the factory's occupying force, just four men, were ushered out and day 102 of the occupation saw the start of a picket at the gates of the Binns Road plant.

Meccano's chief executive, Mr. Derek Dodds, and a small management team, arrived at the factory shortly before 6 o'clock.

Mr. Dodds said: "We have experts in to-day to make sure the factory is made secure, and we will have security staff here 24 hours a day from now on to make sure nobody gets in."

Mr. Dodds made it clear that the company's management had abandoned the idea of finding a buyer, and were taking steps to sell the £2,500,000 of Meccano and Dinky toy stocks on the premises.

He added: "We have over £1,500,000 worth of debts, and to pay our creditors, and to pay off the loan we needed to make the redundancy payments, we intend to sell our stock hopefully to our normal customers."

Factory convener Mr. Frank Bloor, said: "We were expecting the bailiffs at any time, but as it was quiet this morning we let most people go home."

Meccano worker, Mr. Kenny Barr, 41, a former injection mould setter, was in the

building with three trade union supporters, when the bailiffs entered.

Mr. Barr said: "They banged on the door and said they were from the Sheriff's office.

"I was having a doze when I heard the banging, next thing they forced the door with a sledge hammer and pickaxes. About 40 bailiffs and 70 policeman came through and ushered us out.

"There was no violence, but they manhandled us out and they didn't allow us anytime to collect our possessions or to phone the union officials."

Mr. Bloor said: "People are very bitter. They have not been allowed to get their personal possessions out this morning, and some union material is still inside.

"We won't allow any machinery or goods out of the factory. If they want to get anything out they are going to have to use force."

No one was available at the Sheriff's office this morning to comment on the allegations that the occupiers had been manhandled out of the building.

Beatles fans were left grief-stricken on hearing the news of John Lennon's death on 8 December 1980. His childhood home of No. 251 Menlove Avenue is still visited by followers to this day and his music as popular as ever.

9th December 1980, Liverpool Echo

JOHN LENNON SHOT DEAD

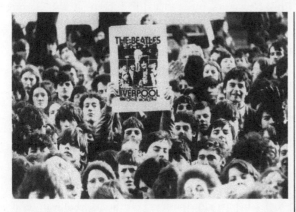

JOHN LENNON, leader of the legendary Liverpool pop group, The Beatles, was shot dead in New York to-day by a crazed gunman.

After a man police described as a local "screwball" pumped five bullets into Lennon, he yelled "I'm shot" and staggered up a few steps into the apartment building where he lived.

And as the 40-years-old superstar lay dying in the arms of his wife, Yoko Ono, he whispered "Help me," according to neighbour Carrie Rouse.

But his final pleas for help in the courtyard of the plush Dakota building were drowned by the sounds of late night revellers discoing to his latest music in bars on Manhattan's upper West Side.

Carrie Rouse said: "Yoko screamed: 'He's been shot, he's been shot. Somebody come quickly.' She was hysterical."

"He was bleeding heavily. His eyes were closed. Then he slowly rolled over."

Lennon died in his wife's arms in the back seat of a Manhattan police car speeding him to hospital.

Police officer John Morgan said Lennon was conscious and moaning when he was put into the back seat of the police car.

"I asked him 'Do you know who you are?'" Officer Morgan said: "And he replied: 'Yes, John Lennon.'"

No more than a couple of minutes later he was dead.

Japanese-born Yoko, aged 47, was at his bedside at New York's Roosevelt Hospital while surgeons began a frenzied battle to bring him back to life.

Massive blood transfusions were given. Half the hospital staff were involved in the fight to save him, using the very latest technology at their disposal.

But within half an hour emergency services director Dr. Stephen Lynn told Yoko: "He never stood a chance. Nothing we were able to do could revive your husband. We believe the first bullet killed him."

Dr. Lynn said that the bullet ripped through Lennon's chest causing irreparable damage to a major artery.

The man arrested and charged with the murder of Lennon is Mark David Chapman (25) of Honolulu, Hawaii, police said.

Chapman was seen at least three times near the Dakota, on Saturday, Sunday, and yesterday,

when he saw Lennon leaving for the studio and got the singer's autograph, police said.

Chapman waited at the Dakota until shortly before 4 a.m. GMT to-day when Lennon and his wife returned in a limousine.

Senior Detective James Sullivan told the Echo this afternoon from his New York office that Chapman, holding a 38-calibre revolver approached the couple from the left side and said: "Mr. Lennon?"

Then Sullivan said, the alleged killer took up combat stance and emptied five shots into the singer's chest.

Chief of Detectives James Sullivan told the Echo this afternoon from his New York office that Chapman would be appearing at Manhattan Criminal Court later to-day. He has been charged with murder and illegal possession of a firearm.

Chapman stood in the courtyard and dropped the empty gun. The doorman kicked it away and an elevator operator picked it up. The fist police on the scene took Chapman into custoy, police said.

Chapman, who wore yellow tinted sunglasses, is a freelance photographer. He was carrying a copy of Lennon's latest album "Double Fantasy" which the ex-Beatle had autographed for him. He

offered no motive for the killing,

Legions of fans who kept vigil outside the plush Dakota building where Lennon lived and died, called for Chapman's blood.

They ignored police appeals to leave the scene. From her secret hideout in New York, where she is mourning her husband's sudden and violent death, Yoko Ono asked for his fans' prayers.

Chapman is a Texan who moved to Hawaii three years ago.

Police said that six weeks ago, Chapman applied for a permit to buy a gun. As he had no criminal record, it was granted.

Lennon and his wife had been at the Record Plant recording studio earlier in the evening and had left there at 10.30 p.m. New York time.

Lennon told studio technicians that he and his wife were going out for supper and then returning home.

Asked why Chapman was allowed to hang around the Dakota for six hours, Sullivan said: "That's not uncommon at the Dakota, a lot of celebrities liver there."

Sullivan said Lennon's limousine could have pulled into the building's courtyard in front of the entrance but instead dropped the Lennon's at

the kerb in front of the Dakota.

Police officer Anthony Palma, one of the first officers at the scene, said they found Lennon lying face down and carried him to a patrol car.

Palma said Yoko became hysterical when doctors told her that Lennon was dead. "Tell me it isn't true," he quoted her as crying.

A passer-by, Sean Strub, said he heard four shots. He said he then saw Lennon being put into the back of a police car.

"Police said he was hit in the back," Strub said.

He said the suspect, a "pudgy kind of man" with brown hair was put into another police car.

"He had a smirk on his face when police took him away," Strub said.

The people of Liverpool were stunned to-day by the shock news of John Lennon's death.

Grief-stricken fans gathered in the cold of Mathew Street.

The site of the Cavern, where Beatlemania was born, has quickly become a shrine to his memory.

"Four lads who shook the world," goes the message under the special street sign, but it was just the death of one that caused the shock waves of grief.

Oona Keating, at 15, was too young to have seen the Beatles in their heyday, but she could hardly speak for tears.

"It's sick," she said "for someone to shoot him. As soon as I heard the news I knew I had to come here.

"I thought I would feel closer to him again. They say it doesn't matter so much because the other three are left, but it really matters to me."

To the 21-year-old Nigel Parkinson of Old Swan, Matthew Street, seemed the natural place to come to remember John Lennon.

"I just felt I had to come. It's tragic that someone who was always singing about peace and love should have been killed by the assassin's bullet. But no one will ever be able to kill his music."

And there was a pall of sadness over Lennon's old school of Quarry Bank in Liverpool.

Teachers announced the magic news to their stunned pupils at assemblies this morning.

Mr. John Chapman, acting headmaster, said that even now parties of tourists visited the school where the rock star spent his years from 11 to 15.

"It's quite incredible but still we have people mostly Japanese tourists, arriving and wanting to photograph the front of the school.

"Even in the last few weeks we have had some Japanese students here.

"And two or three years ago we had Japanese television in doing a series on him."

The Quarry Bank Files record that John Winston Lennon arrived at the school on September 4, 1952 and left to go to the College of Art on July 24, 1957.

Mr. Chapman went on: "We are obviously sad. It is a sense of pride that he came her because whether you happen to be a Beatles fan or not. John Lennon was a major influence on music.

"Music as it is to-day wouldn't have been the same without him and we have always been proud of that connection.

"It's possible that we will use some of his music next Monday at our carol concert as tribute."

More than 2,000 police officers were called to Toxteth as riots broke out in July 1981. The events were an accumulation of social tensions and poor relations between the authorities and the local community, and followed the Brixton Riots in London earlier that year.

6th July 1981, Liverpool Echo

TOXTETH LANDMARKS IN RUINS

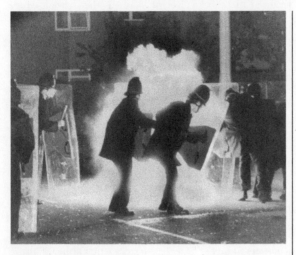

The devastated Toxteth area of Liverpool was to-day counting the multi-million pound cost of a second night of rioting, which left 200 policemen injured and scores of shops wrecked and looted.

Police regained control after seven hours of bloody street battles, during which they were under constant attack by mobs of rampaging youths–and at one stage were forced to use CS gas to fight back the rioters.

To-day, the Toxteth area was scarred with burnt-out vehicles, flattened bus shelters and lamp-posts, and broken glass and rubble.

In Lodge Lane, shopkeepers were clearing up and assessing the damage–and some claimed they had to arm themselves against what they described as 'organised' gangs of looters brandishing machettes and cleavers.

And, at a Press conference to-day at Merseyside Police Headquarters, Deputy Chief Constable Mr. Peter Wright said 185 officers were taken to hospitals after last night's violence and 43 are still detained, one with a fractured skull.

A total of 70 arrests were made for public order and looting offences.

Eight hundred policemen were used to combat rampaging gangs, totalling about 500, last night and senior officers said to-day that even more police would be on duty to-night.

C.S gas canister would again be available for use.

Mr. Wright described the violence as being at 'a level beyond my experience.'

He said last night's violence began at 7.45, when youths broke into a dairy and removed floats. Police were attacked and police reinforcements ambushed. Rocks iron bars, petrol bombs and vehicles were driven at them.

'A number of groups were involved and many officers attacked in side streets. The tactics used were basically the only ones we could use with the instruments the police had.

In the end, we were forced to use about 25 C.S. gas canisters.'

The police chief said he was satisfied with the way his officers had handled the riot.

'We deployed our resources to the main area of threat, which in our opinion was Upper Parliament Street. The conclusions that some people draw that the police could have done something in Lodge Lane, but didn't, is totally wrong,' he said.

He said police were not happy with the incidents in Lodge Lane and the situation may be handled differently if there was a similar outbreak.

Mr. Wright said it was feared to-night could see a repetition of the violence. There would probably be more uniformed officers available from neighbouring forces.

But the possibility of troops being brought in has been ruled out, he added.

He appealed to parents to keep their children at home.

Mr. Wright said police equipments against the weapons used by the mob were very limited.

And he said the police considered 'their is some orchestration' of the rioting.

Most of the people involved in the riots lived in Toxteth and did not seem to be under the control of their parents.

Senior police officers were meeting today to see what lessons could be learned form the weekend riots.

'But if police are faced with attack from 500 people, we are very limited in our choice of tactics.' Said Mr Wright.

The injuries being suffered by our officers last night were such that the use of C.S. gas was right. I have no knowledge of C.S. gas being used before on the mainland in a public order situation.

We cannot allow our officers to suffer brutality

without some means to reduce the level of attack. We know there are rubber bullets available. Whether we use them on Merseyside is a judgement we will have to take later.'

Police Federation chairman, Mr. Jim Jardine said: 'We must have better protection, even if that means the loss of the traditional look of policemen in situations of crowd disturbance.'

He called for crash helmets to prevent head injuries, as well as protective clothing and urged that police should wade in and arrest ringleaders in flare-ups.

Pope John Paul II visited Britain in 1982. It was the first time that a pope had visited the country in over 400 years. It was said that a million people lined the route of the Holy Father on his arrival at Speke Airport onwards to the city centre.

1st June 1982, Liverpool Echo

HE CAME, HE SAW AND HE CONQUERED

"Thank you very much"

The most heartfelt emotions can be summed up in the simplest of phrases, and those four small words were all that a Pope needed to prove to the Church Omnipotent and the world that he had taken Liverpool to his heart.

They appeared on no programme or service sheet. They were the spontaneous and loudly proclaimed thanks of the 246th successor of St. Peter as he concluded his blessing at the altar of Liverpool's Anglican Cathedral facing the largest ecumenical gathering ever assembled on Merseyside.

Only minutes later, in Toxeth, as he made his way from Liverpool Airport to the largest church in the Anglican communion, he had turned to bless a small pocket of Protestant protestors, still recalling the words of John Ryle, the first Bishop of Liverpool: "Beware of countenancing any retrograde movement in the country towards Rome..."

But once at the great west doors of this great cathedral, he was made aware of man's willingness to bury differences in what was once the city of the orange and the green.

There to greet him was David, sixth Bishop of Liverpool. And as the massive doors of the cathedral were flung open wide to the sound of brass fanfares and organ music and singing, the pages of the old history books were firmly closed,

Within seconds the loudest noise in the building was that of clapping hands, acclaimed by the Psalmists of old.

The tanned, slightly-stooped figure of a man in a white skullcap was dwarfed as it made its way up the Nave beneath the highest Gothic arches ever constructed, designed by Sir Giles Gilbert Scott, himself a convert to Roman Catholicism. Above, in the tower, the world's loftiest peal of bells rang out.

There could be no greater setting for John Paul, Superstar to set the seal on the story of Hope Street, where at either end, two great Christian families had raised their hopes to the skies as twentieth century acts of faith.

The Pope was overwhelmed by the grandeur of the event and overcome by the enthusiasm of his welcome, and at no time was his smile more telling than when, with characteristic unpredictability he moved from the altar steps to congratulate the choir, under their director, Ian Tracey, on the singing of a Christmas carol from his native Poland.

Great Christian families
The congregation, too, were as spontaneous as the Pontiff as they added further dimension to all the clapping and the singing with three resounding cheers.

The ecumenical service at Canterbury Cathedral on Saturday may have been the standard bearer for Christian unity in Britain, but it was in Liverpool Cathedral that the Pope most truly felt the groundswell of support for that initiative.

And it was from there that he left for an historic journey down Hope Street, to be with his own flock at the Metropolitan Cathedral on the fifteenth anniversary of its consecration.

It was the late Cardinal Heenan, then Archbishop of Liverpool, who two decades ago inverted the title of Liverpool's famous road and incorporated it into the oft-quoted phrase of a "a street called Hope".

For a time, the spirit of ecumenism went little beyond lip service, but, latterly, it has grown into a unique phenomenon in British Christian kinsmanship, with both cathedrals exchanging preachers and choirs and visitors.

John Paul's journey down that road, also known for its colleges and arts venues and pubs, was the full blossoming of that spirit of togetherness.

Outside the Metropolitan Cathedral, a crowd of 2,000 young people raised their voices in song: "Let there be love shared among us, let there be peace shared among us," they proclaimed.

When he faced the capacity congregation inside Frederick Gibberd's more modern Space Age cathedral, the Pope was immediate and eloquent in his appeal of reconciliation.

"The sin of disunity among Christians, which has been with us for centuries, weighs heavily upon the church," he said. "A restoration of unity among Christians is one of the main concerns of the church in the last part of the twentieth century."

"This task is for us all. No one can claim exemption from this responsibility."

In his welcome to the Pope, Archbishop Derek Worlock, the man most responsible for salvaging the Papal trip from the entanglements of a war 8,000 miles away, said that he hoped that the Hope Street journey would light a torch for reconciliation.

Meanwhile, the Pontecostal Mass, like everything else on this most memorable of days, was lit by bright sunlight and warmed by an outside temperature of 75 degrees Fahrenheit.

But it was not just the shade temperature that made the Pope feel as if he was home among the more familiar Vatican pilgrims.

It was the vocal strength and unity of the crowds who lined his route and whose enthusiasm more than compensated for a smaller turn-out than the organisers had expected.

Many had stayed at home to watch the Liverpool visit on television, perhaps put off by the anticipation of crowds so large as to obscure a glimpse of the Pope from lesser vantage points.

Yet, as it was, many people were able to leave the Anglican Cathedral

and move down Hope Street in time to see the Holy Father's arrival at Brownlow Hill.

Even at the airport, the attendance had been about half of what was expected.

But 150,000 people are still capable of making a welter of noise – and they did.

From the minute the Pope stepped from the helicopter and his skullcap blew off, you could feel the Liverpool visit was going to be different.

And within minutes the Pope was demonstrating his outstanding ability at splicing together the formal and informal aspects of his British visit.

The Waltons became the talk of the town after becoming parents to healthy sextuplets on 18 November 1983. They are the world's only known surviving all-female set.

19th November 1983, Liverpool Echo

MY SMASHING SUPER BABIES

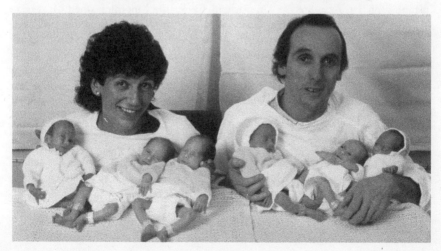

I'm over the moon, says father-of-six

The delighted father of sextuplets born in Liverpool told the world to-day: "They're smashing."

A tired and nervous looking Graham Walton left his happy wife Janet to face a crowded press conference and talk about his instant family of six daughters.

He had just been paying a second visit to the intensive care unit at Liverpool's Oxford Street Maternity Hospital where the tiny girls are doing fine in incubators.

His 31-year-old bank worker wife had just seen them for the first time. They were born within four minutes of each other by caesarean section last night.

"They're lovely. I'm over the moon," said the Wallasey painter and decorator, from Browning Road, Wallasey.

When asked if he was planning on having more children he laughed: "Not at the moment."

He said they had known for some months it was going to be a multiple birth, but they had originally expected five children.

It was just three weeks ago that doctors told them Janet was having six. Mrs. Walton was taken into hospital in May when it was discovered it would be a multiple birth.

The couple have been married for seven years, and for the last five of those have been taking a fertility drug.

Mr. Walton told waiting journalists: "After all that we have been through in the last five months it was just sheer relief I felt when I saw them. I couldn't believe it."

Mr. Walton sat next to the family solicitor Mr. Rex Makin during the conference.

The morning press conference at the hospital had been delayed for half an hour so that Mrs. Walton could get her first look at the little girls.

Then she and her husband discussed their health with the doctors.

The amazing odds against the all-girl sextuplets were given by medical staff at the hospital as 3¼ billion-to-one.

Dr. Richard Cook, the consultant neo natal paedaectrician, released details of the weights of the new born babies.

Giving numbers to the unnamed children he said the first-born weighed 2lbs 1oz, No. 2 weighed 2lbs 15ozs, No. 3 weighed 2lbs 11ozs, No. 4 weighed 2lbs 5ozs, No. 5 weighed 2lbs 13ozs and No. 6 weighed 2lbs 9ozs.

Dr. Cook said the fourth baby started crying as soon as she was born, and, he said, "has carried on crying ever since."

He said three if the other babies are now breathing normally and have been taken off respirators.

The second baby born was still on a ventilator, although "getting better all the time," and the third baby born is on a ventilator but "improving".

Dr. Cook said the babies were not identical. They differed in facial expression, size and hair colouring which ranges from pale mousey to quite dark.

The family's solicitor Mr. Rex Martin, was negotiating with representatives of national newspapers who are wanting to buy up the family.

Figures of £200,000 plus were being bandied around at the hospital this morning when Mr. Makin entered the room set aside for the pressmen: "I don't want to be sordid but if anyone has a cheque book with them we may be able to do something to-day."

Through Mr. Makin the family has appointed a Liverpool public relations consultancy firm to handle publicity for them in the future.

In 1984 a mass of 50,000 people marched to the Town Hall in protest against measures by Margaret Thatcher's Tory Government. It was one of the largest demonstrations in living memory.

29th March 1984, Liverpool Echo

VICTORY WILL BE OURS SAYS HAMILTON.

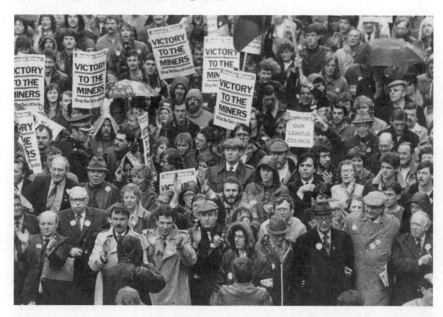

A demonstration of "unqualified support" for Liverpool City Council's budget stand, was how council leader Councillor John Hamilton described today's mass rally.

Speaking from the Town Hall balcony to the crowds of marchers who had gathered at the Castle Street junction below, Councillor Hamilton said:

"This is a fight to make sure the working people of Liverpool get the opportunity to live a decent life, which is now under threat by the Tory Government.

"Whatever happens," he said "the final victory will be ours.

Problems
"There may be many problems along the way, but the message to the Tory Government is clear. The working people of Liverpool will not stand for this kind of treatment."

City council deputy Leader, Councillor Derek Hatton said:

"When we were elected last May, we said we would do what we had promised to do before we were elected. We said we would have the support of the vast majority of the people of this city.

"Today is the largest strike that has ever

been seen in this country. The Labour Party will not flinch and the Tory Government will have to listen more than ever before.

"If Mrs. Thatcher wants somebody to do her dirty work, she will have to do it herself, or through the help of the Liberals. We will not do it for her."

National chairman of the Labour Party, Mr. Eric Heffer, MP, said he offered his unqualified support for what the city council was doing.

Earlier, city councillors, MPs and Merseyside county councillors led a huge march through the city centre to the Town Hall.

The original Cavern Club had opened in the 1950s as a Jazz club, but over the years the venue grew popular with skiffle groups. It shut down in 1973 when British Rail enforced its closure to allow work on a ventilation shaft which never materialised. On 26 April 1986 a replica of the original Cavern Club opened in Mathew Street and now welcomes thousands of music lovers every year.

Liverpool Echo

YESTERDAY ALL MY TROUBLES SEEMED SO FAR AWAY

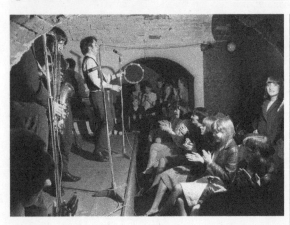

The Beatles are back at Cavern

Liverpool's legendary Beatles were back where it all began today—at the Cavern in Mathew Street.

But this time around—20 years on from their halcyon Merseybeat days—they came in the shape of a £40,000 life-size bronze statue, the centrepiece of the new £9,000,000 Cavern Walks development.

None of the three surviving Beatles, though invited, turned up in person for the opening of the prestige office, shopping and leisure complex, developed by Liverpool-based Royal Life Assurance.

But the Beatles connection was maintained by the presence of Mike McCartney, brother of Paul, who carried out the unveiling of the statue.

The luxury development featuring trailing plants, vaulted ceilings and tinted glass, is a far cry from the grimy old Cavern night club which stood on the site until it fell before the bulldozers.

And Mike McCartnet said "Bulldozing the old Cavern was a monumental disaster, but that is in the past. This is the actual of where it all took place, 20 years ago, and that's the most important thing.

"This is just one of the many things going on this year which will hopefully bring attention back to the city, the likes of which it hasn't seen since those Merseybeat days."

The club is sited in the basement of the complex, and uses 15,000 original bricks from the old Cavern to recreate the atmosphere.

But one not impressed by the new Beatles statue was Sam Leach, one of the first promoters of the Beatles.

He said: "It's a load of rubbish. The only one I recognise is Ringo, and that is only because he has a drum stick in his hand."

An Echo Of Lennon

Cynthia Lennon took a tearful tug at a copy of the Liverpool Echo today, to reveal a special tribute to the former husband John Lennon in the city centre.

The copy of the Echo had been used instead of traditional curtain to cover a wall plaque on the side of the new Cavern Walks £7 million shops and office complex, which was officially opened today.

Cynthia, one of the guests of honour at the opening, slipped away to perform her own simple ceremony to the murdered Beatle.

"It's just my tribute to John, I was delighted when I was told I could have a plaque placed on the building. We used and Echo because that is something John would have like, said Cynthia, who designed the murals on the outside walls of the Cavern Walks site.

The plaque reads "To John" and quotes the first verse of his song, In My Life. "That says it all," said Cynthia.

Tonight, the replica of The Cavern Club will throb again to the sounds of Merseybeat as the club opens to a celebrity audience. Among the groups appearing are The Swinging Blue Jeans. Bill J. Kramer, and The Merseybeats. Comedian Jimmy Tarbuck will compere the event.

A fitting nautical event for Liverpool, the Tall Ships Race is now a regular crowd-pleaser with vessels from all over the world taking part.

4th August 1984, Liverpool Echo

SAIL OF THE CENTURY

A million-strong crowd was converging on the banks of the Mersey today for the historic Tall Ships Parade.

Spectators were up early to grab the best viewing positions to watch the 70 majestic ships in the most spectacular display of sail the port has seen in 160 years.

The Queen, Prince Andrew and Princess

Anne's children Peter and Zara Phillips will get their own unique view from the Royal Yacht Britannia, which was due to moor off Liverpool's Alexandra dock just after 4 p.m. with a Royal Navy escort.

The parade, led by the British sail training ship Sir Winston Churchill, will take 90 minutes to file past Liverpool's Pier Head.

The first ships were being locked out of the docks system at 5 a.m. ready to be grouped in tight formation alongside Liverpool's International Garden Festival site.

Among the first on the Mersey were the 3,185 ton square-rigger Kruzenshtern, the white-hulled Gorch Fock, from Germany and the Gloria from Columbia.

They were followed by the schooners, ketches, barques and cutters making up the 60-strong armada as the crowds gathered with an eager air of anticipation.

A flotilla of pleasure craft was bobbing and jostling for best position to watch the ships unfurl their sails and strike out for Liverpool Bay.

The romance of the square riggers has proved a magnetic draw with more than 100,000 visitors flooding into the Albert and Vittoria Docks to get close-ups of the vessels at berth over the last three days.

And Merseyside will bid a fond farewell in true Scouse style when the fleet—which transformed the port into a bustling hive of activity—sails out of the river.

The Albert Dock had opened in 1846 but fell into obsolescence. In 1988 the dock was redeveloped as a tourist destination and now one of the country's leading attractions.

24th May 1988, Liverpool Echo

ROYAL TATE AND STYLE

Prince's praise for the pride of Merseyside – 'a symbol of fresh hope'

Prince Charles, the scourge of modern architecture, today showered praise on the Albert Dock, Liverpool's dockland showpiece, and saw it as a symbol of fresh hope for the region.

Thousands of cheering people greeted the Prince, who was on Merseyside for a full day of engagements, including the official re-opening of the Albert Dock and Tate Gallery of Modern Art, which is included in the complex.

The Prince gave his Royal seal of approval to the business partnership, which has turned the derelict dockside into the pride of Merseyside and he slammed plans back in the sixties and seventies to tear the docks down to make way for office blocks.

He said "I think they have done a remarkable job and they should be congratulated I hope this will be an inspirations in other parts of the country.

"It is certainly a great pleasure to be able to come here today and make a small contribution to the restoration of this magnificent set of industrial buildings.

"Having seen it, it will provide a symbol of new purpose, fresh hope in Liverpool and I have enormous pleasure in opening it"

And he added: "In many ways I am extremely delighted to see these buildings give added and renewed pleasure to the people of Liverpool."

The Hillsborough disaster remains as one of the most serious tragedies in sporting history. Ninety-six men, women and children lost their lives on 15 April 1989.

16th April 1989

THOUSANDS RUSHED ON TO TERRACE WITH THE FORCE OF A GUIDED MISSILE

The gateway to disaster

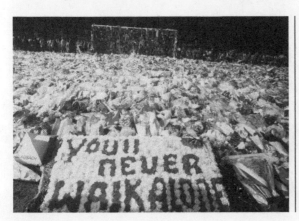

This should have been the report of a football match, an F.A. Cup semi-final between two of the finest teams in English soccer.

Instead it is the almost unbelievable, terrifying story of the greatest disaster in British sport, a repeat of that dreadful night four years ago when 39 people died at the Heysel Stadium in Belgium.

With the sun shining benignly on what should have been the friendliest of occasions, Hillsborough was suddenly plunged into sheer horror. Almost before we had realised it twice as many fans, virtually all from Liverpool, as perished at Heysel had died in a deadly melee caused by the late entry of about 2,000 late comers.

Exactly why the great gates in the perimeter were opened will have to be established by an official inquiry, but there is no doubt that the basic cause of this terrible disaster was the rush of several thousand people into a congested terrace with the force of a guided missile.

Fans throng the pitch

Suddenly a football match had become a national disaster, with players, policemen, firemen and supporters of both clubs rushing to carry inert bodies away to waiting ambulances. Fans thronged the pitch, many unaware of what had happened but having little idea of what to do next, while an army of policemen kept the peace.

The sickening events of 12 February 1993 will never be forgotten. It was then that three-year-old James Bulger was abducted and gratuitously tortured and killed at the hands of Robert Thompson and Jon Venables both aged ten. There were found guilty of murder and sentenced to custody until adulthood. They have since been controversially released with new identities.

13th February 1993, Liverpool Echo

YOUTHS SOUGHT AFTER TODDLER JAMES IS ABDUCTED
FIND THESE TWO BOYS

By Ray Kelly and Philippa Bellis

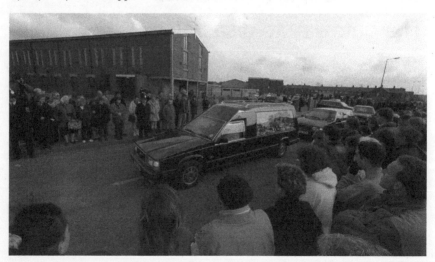

Police this afternoon released this dramatic videotape picture in their hunt for missing Merseyside toddler James Bulger.

It shows one of two youths being sought leading James away from a Bootle shopping centre.

Earlier James's mum Denise broke down in tears as she made an emotional public appeal for the return of her missing two-year-old son.

"If you have got my baby, PLEASE bring him back."

Police now believe that James was abducted by two youths from the New Strand shopping centre, in Bootle, yesterday afternoon.

They have video evidence of James with two youths, both of them little more than school age.

Supt Mike Hogarth, who is leading the massive hunt for James, said that police are very concerned for his safety.

He said there have been a number of unconfirmed sightings—including some around the canal area which police divers were searching today.

Sup Hogarth said: "We can confirm that James was with two young people who left the Strand, turning right towards Liverpool."

"That would put them in the vicinity of the canal

"We are treating the canal as a serious sighting, because we have another report that he was seen round that area."

Supt Hogarth appealed for a number of young people seen in the area to come forward, so they can be eliminated from inquiries.

He said: "It is vital to talk to them as soon as possible. We also know that two people fitting the description of the youths were seen in the Mons Square area."

Detectives are also investigating one eye-witness report, of a youngster resembling James, who was given a ride on the shoulders of a teenager along the canal tow path around that time.

After James's mum was helped away in tears from the room at the police station, her husband Ralph steeled himself to go back alone, and speak about their "bubbly little boy" from Oak Towers, Northwood, Kirkby.

He said: "He's a bubbly little boy, he would get on with everyone."

The Liverpool Institute for Performing Arts (LIPA) is one of the United Kingdom's leading institutions for performing arts and offers training across multiple disciplines. It was the brainchild of Sir Paul McCartney and Mark Featherstone-Witty, officially opening on 7 June 1996.

7th June 1996, Liverpool Echo

ROYAL VISIT

By Ann Todd and Caroline Storah

The Queen was said you have hugely impressed with the talent on show during her trip around the Fame School, adding that she loved the place.

Paul McCartney gave the royal visitor a tour of LIPA and was delighted with her response.

He said: "She was very entertained with it and thought it was of high quality. "She loved the place."

But he played down rumours he is about to get a knighthood in the Birthday Honours list saying: "It is too embarrassing to think about."

Pressed further, he quipped: "I know nothing about it."

Linda has recently been fighting breast cancer.

But Paul added: "She is well."

After the Queen departed, he waved to the screaming crowds who were calling out: "Sir Paul."

Crowd

On his arrival today, Paul thrilled tow of his youngest fans, Laura Harris, 14, from Litherland and Kirstie Goscombe, 15, from Bootle.

The girls had been waiting behind a barrier outside LIPA for two hours, and when Paul spotted the crowd he went over to speak to them.

Laura said: "Paul was great. He came over and shook our hands and say hello.

"I won't wash my hands for a week."

Kirstie said: "Paul was lovely and very friendly. I'm a big fan of the Beatles, and Ringo is my favourite."

Emma-Jane Stevens, 17, travelled from Halifax to get a glimpse of Paul.

She said: "I love the Beatle's music and that's why I came specially to Liverpool to see Paul. He looked just great."

Inside the historic building the Queen first visited a performance of contemporary dance.

One of the performers, Beth Olsen, 20, from Birmingham, said: "We have been working for this day for a while, I was nervous but excited."

In a trip to the recording studio McCartney, swopped stories with technicians, while singer Julie Thompson, 27, performed

"Perfect World", composed specially for the day.

She said "I was very nervous - imagine the Queen and Paul McCartney in one room."

After the Queen unveiled the plaque, LIPA chief Mark Featherstone-Witty told her: "We first wrote to you in 1991 when this room and building were completely derelict.

"We asked for your support and you gave it to us. We thank you for your faith in our dream."

Pensioner Sheila Jones, 67, who has recently sold Paul McCartney's old house in Forthlin Road, Allerton, was among the crowd.

Mrs Jones, who has now moved to live with her family in Heswall, said: "The Queen and Paul both look absolutely fabulous. It was well worth coming to see them."

In the final days of 1999 Liverpool bid farewell to the twentieth century and looked forward to a brighter future.

30th December 1999, Liverpool Echo

FAREWELL TO THE 20TH CENTURY

!999 year began with Liverpool in the spotlight when the controversial police documentary Mersey Blues hit our screens in JANUARY.

Liverpool legend Bill Shankly honoured by FIFA in the International Football Hall of Champions for his achievements at Anfield and, in the same month, LFC opened its £10m academy to nurture young talent. Ashworth hospital avoided closure despite a damning report which detailed child sex, drinking and rug-taking at the hospital.

FEBRUARY saw Michael Owen crowned as the ECHO's Merseyside sports personality of the year (below) and the star decided to stay loyal to Liverpool, rejecting a £25m bid by Italian club Lazio.

Beryl Bainbridge's attack on the Scouse accent as "nasal and stupid" provoked outrage in MARCH, but Merseyside was on the up after securing more than £630m of European funding.Liverpool striker Robbie Fowler was charged with misconduct by the FA after a feud with Graeme Le Saux, while team mate Steve McManaman prepared to head for Spain after signing for Real Madrid. March was also a month of medical success – the Roy Castle Lung Cancer Foundation discovered a way of detecting lung cancer two years

before it develops. There as a breakthrough for the families of those who died at Hillsborough when the high court ruled the two ex-South Yorkshire police officers would be prosecuted for manslaughter. And Liverpool stood still in memory of the 96 victims in April on the 10th anniversary of the tragedy.

City centre street traders were up in arms in MAY when they were told they had to clear off their Church Street pitches within 90 days.

The curtain rose on Phantom of the Opera at the Empire and hundreds of angry holiday makers camped outside Liverpool's passport office in JUNE after a new computer system caused a back-log of applications.

Evertonians breathed a sigh of relief in JULY when relegation saviour Kevin Campbell officially signed for the Blues.The stars were out in force as filming began on the streets for the Dickens classic David Copperfield. Eclipse fever gripped the nation in AUGUST when thou-

sands stopped to watch the moment Merseyside was plunged into darkness.

Liverpool launched its bid to be European City of Culture in 2007 on its 800th birthday without the help of ambassador Julie Goodyear, who lost her controversial position.

Residents in Anfield were protesting over plans to expand the Red's stadium, while former LFC boss, Roy Evans, splashed out more than £5,000 on a pair of Bill Shankley's boots which he used to clean as a boy.

October continued on this sad note with the discovery of hundreds of dead babies' hearts and organs stored in Alder Hey Children's Hospital and with the news that Cilla Black's promotor husband Bobby had died of cancer.

Linda Wood, who saved the life of her two-year-old granddaughter by phoning the meningitis helpline, was named ECHO Mersey Marvel of the year in NOVEMBER.

Another marvellous Merseysider Ricky Tomlinson, of The Royle Family fame, swept the board at the Scousology Awards, picking up honours in the comedy and television categories.

The big news in DECEMBER was Sir Paul McCartney's return to Liverpool to play at the Cavern.

There was outrage when the European Court of Human Rights ruled that the killers of Liverpool toddler James Bulger did not have a fair trial. The judges said the human rights of Jon Venables and Robert Thompson had been violated when they tried in adult court.

Theatre impresario Bill Kenwright handed Evertonians the perfect Christmas present by putting an end to the 13-month takeover saga and signing a deal at the club.

And the countdown to the new Millennium began with Merseysiders gearing themselves up for the biggest party Liverpool, has ever seen.

Liverpool airport honoured one its most famous sons with a rebrand on 2 July 2001. The airport was officially renamed John Lennon Airport by the musician's widow Yoko Ono.

2nd July 2001, Liverpool Echo

JET BACK TO WHERE HE ONCE BELONGED! YOKO HEADS TRIBUTE TO JOHN

Yoko Ono flew into Liverpool today and renamed the airport in memory of her late husband, John Lennon.

She officially unveiled the airport's new identity and its new logo: "Liverpool John Lennon Airport; above us only sky."

Wearing a black trouser suit and purple-lensed sunglasses, Yoko said: "I am delighted that Liverpool Airport has decided to choose John's name.

"John was always remembered for his sense of fun in life and I hope that John

Lennon Airport will send a big smile to all corners of the world."

Before unveiling the new name and logo, Yoko said: "As John said, 'There is no hell below – above us only sky.' John would have been very proud."

The airport's biggest customer, easyJet, welcomed the name change.

"We support this bold move whole-heartedly," said a spokesman.

Yoko also called for the city of Liverpool to transform John's childhood home, on Menlove Avenue into a museum about her late husband.

The UK's largest festival of African music, Africa Oyé, was forced to move to Sefton Park in the summer of 2002 in response to its huge popularity.

24th June 2002, Liverpool Echo

MERSEY BEAT THOUSANDS ENJOY AFRICAN MUSIC IN SEFTON PARK

By Thomas Martin

Africa came to Sefton Park – and so did the glorious African sunshine.

Tens of thousands of people flocked to Liverpool's biggest park for Europe's largest free African music festival.

Brother Resistance from Trinidad were among five bands playing yesterday as part of part of the tenth Africa Oyé festival.

Organisers said it was the biggest turnout in the festival's history as families with picnic hampers were out in force for the colourful annual event.

Brother Resistance, the inventors of musical style Rapso, were joined by performers from Mozambique, Nigeria, Kenya, Senegal and Morocco in a seven-hour musical marathon.

Africa Oyé spokesman Paul Duhaney said: "We have had beautiful sunshine and people seem to have really enjoyed themselves – it's been very much a family event with people taking picnic baskets and sunbathing.

"Liverpool was the first place African music arrived in this country and has a profound effect on the area and its music heritage.

"Africa Oyé means 'listen to Africa,' and people have really appreciated the music they've heard.

"The festival has succeeded in bringing together all sections of the community – the whole festival is free and there are no barriers at all to people's enjoyment."

The party in the park was the climax of the 13-day festival which saw concerts and workshops across Merseyside.

Established more than 10 years ago, the festival, the biggest free event of its kind in the country, has developed an international reputation for breaking new artists onto the European music scene.

A turning point for the city came on 4 June 2003 when Liverpool was announced as Europe's Capital of Culture for 2008. This moment was a real catalyst to the city's now famous renaissance.

4th June 2003, Liverpool Echo

IT'S TIME TO CELEBRATE, PARTY BEGINS AFTER JOWELL ANNOUNCES CITY CULTURE TRIUMPH.

By Joe Riley & Matt Slater.

These were the dramatic scenes today as Liverpool was crowned European Capital of Culture 2008.

The city beat its opponents – and the bookmakers who ranked Newcastle as favourites to land an accolade which will create 15,000 jobs and bring more than £200m into the city.

Bid leaders joined ordinary people in jubilant celebration as the announcement was made at 8.10am in London today by Culture Secretary Tessa Jowell.

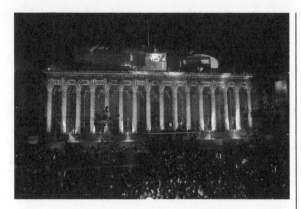

She sparked incredible scenes with the simple words: "The winner is ... Liverpool."

The news was greeted with sheer joy as it was broadcast live to a packed Empire Theatre in the city centre. At the same time, taxi drivers in Lime Street sounded their horns. In contrast, the decision was greeted by tears in Newcastle and Birmingham.

Now the party can really begin as Liverpool gears up for two fantastic years – its 800th birthday in 2007 and as Capital of Culture the following year.

The city can proudly boast its status as the Capital of Europe ... but it will also mean hard cash coming into the economy.

Tourism in 2008 will attract 1.7 million people and, in the years leading up to it, visitors will spend £220m in the city.

The total investment in the city over the next five years is expected to be an extra £2bn.

Tessa Jowell headed straight for Liverpool after making the announcement, and was being taken on a tour of the city to see for herself what made the 12 judges choose our bid.

Tessa Jowell was arriving at Lime Street station with chairman of the judges Sir Jeremy Isaacs, to be met by the lord mayor, Cllr Ron Gould, and bid leaders.

Schoolchildren with home-made placards waited for them, along with a military band.

The secretary of state was being taken to the Empire Theatre to formally hand over the Prime Minister's letter of congratulations to the city of Liverpool. There were cultural events at St. George's plateau and a tour of St. George's Hall before the return to London.

After that, a huge party was being thrown at the town hall.

Immediately after today's announcement, bid leader Sir Bob Scott pledged: "We now have a

big responsibility to represent Great Britain and show what we can do. I am sure we can be the greatest European Capital of Culture that Britain has ever seen.

"This is a fantastic day and is a reward for the hard work that we have done since the bid began."

Liverpool council leader Mike Storey summed up the mood of the city, saying: "This is as good as Liverpool winning the Champion's League, Everton winning the double and the Beatle's getting back together.

"I am really proud and this gives us the opportunity to make real changes in the future and make things better.

"It is an honour which will transform Liverpool forever and a lot of people have worked extremely hard to get us the title."

City council chief executive David Henshaw added: "There will be so much to gain from being named Capital of Culture in 2008.

"The city will look at June 4 as the moment we finally began to realise our true potential as a world city."

The creative director of Liverpool's bid, Sue Woodward, said: "Liverpool's time has come. The judges have placed their faith in us and we must deliver."

A huge media pack gathered in the glass atrium at

the Liverpool Empire to capture the moment the city was told it had won,

Sir Paul McCartney said: "I've been rooting for Liverpool to win this honour ever since I first heard about it. Now it has really happened, it is brilliant news.

"Liverpool is not just Capital of Culture, it's the capital of the universe! It deserves this honour in so many ways."

Liverpool hotels boss Stephen Roberts said: "This is the best news the city has had this century.

"It will be a tremendous shot in the arm for all the hotels and raises tourism to another level."

Liverpool brewer Cains is to bring back its limited edition 2008 Ale in tribute to the Capital of Culture success.

The specially-brewed ale sold out almost immediately when it was released as part of the city's campaign for the title.

Liverpool's best known television soap Brookside aired its final episode on 2 November 2003. The soap pushed many boundaries during its twenty-one year history and featured many award-winning storylines. The Croxteth set of Brookside Close is has since been sold to private developers.

5th November 2003, Liverpool Echo

OUT WITH A BANG – AND A WHIMPER

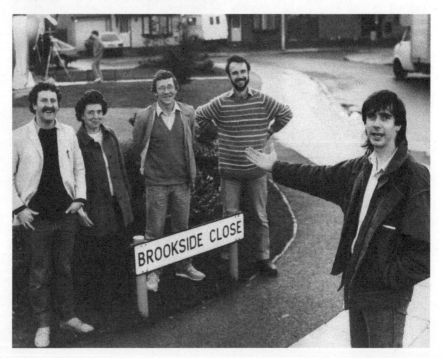

Kids on LSD and crack cocaine and a drug dealer neighbour from hell hung out to die ...

And there was me thinking the last Brookside was going to be something out of the ordinary.

Brookie went out with a bang (psycho baddie Jack Michaelson – not at all inspired by former Channel 4 chief executive Michael Jackson – being strung up by his neighbours) and then a whimper ... a bizarre self-indulgent speech from Jimmy Corkhill.

Although it may not have cut the mustard for years, the show was once loved by millions – and yet some clueless commentators claimed Phil Redmond's beloved pet would be put down within weeks of it being born.

It was November 1982 and the tabloid press didn't like what it saw on "Channel Swore" – although S*n journalists bravely sat through Brookie to conduct a "day-by-day filth count" (the number of so-called swear words used in the programme).

That it made it to its 21st birthday is then a major achievement ... although sadly when C4 handed Phil the key to the door it turned out to be the key to the soap cemetery.

Liverpool Football Club added another trophy to their cabinet after securing an unexpected victory against AC Millan on 26 May 2005.

26th May 2005, Liverpool Echo

VICTORY PARADE REDS FANS LINE THE STREETS TO CHEER CHAMPIONS

By Jon Tunnet and Tony Barrett

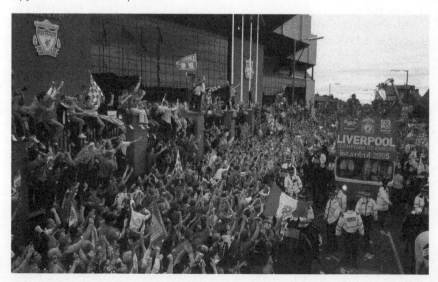

Liverpool's conquering heroes were returning to a rapturous welcome from about 500,000 fans today.

Ecstatic supporters began lining the route of the victory parade hours before the open-top bus was set to begin its triumphant journey.

An estimated 400,000 turned out for Liverpool's last huge celebration when the treble-winning side toured the city's streets in 2001.

But council and police chiefs expected that figure to be dwarfed today with Reds fans streaming into the city from all over the country.

Airport chaos in Istanbul left fans facing up to six-hour delays in getting back to Liverpool. Many were likely to miss out on the parade as a result.

Those remaining in Istanbul for an extra day had enjoyed an appearance by Rafa Benitez and his victorious squad.

They emerged from their team hotel clutching the precious silverware – which will now remain in the club trophy cabinet for good as a mark of Liverpool's fifth coronation as champions of Europe.

Club officials had planned the victory parade in advance, with aid from the city council and Merseyside police.

But superstition prevented the full details being released until the victorious conclusion of last night's dramatic match.

The route was planned to give fans plenty of opportunity to view their heroes from a number of vantage spots in the hope of spreading the huge weight of supporters.

But despite the hopes of easing the burden, it was still expected that the vast majority of supporters would congregate at Anfield and in the area around St George's Hall, where the parade was set to end.

Civic chiefs hinted there might be a surprise for well-wishers, but they were staying tight-lipped about final arrangements.

Meanwhile, a very special party was kicking off in a different part of Merseyside.

Family members of Steven Gerrard were beginning their celebrations in Huyton in anticipation of him bringing the trophy home.

Joan Dooley, the Liverpool captain's aunt, said she wept with joy as her nephew lifted the trophy.

She said: "It is so hard to find the words to explain how I felt and how all of Steven's family feel.

"I remember watching him playing football in the street wearing only his nappy,

"Who could have guessed that little lad would grow up to be such a hero?"

She said many family members travelled to Istanbul, but she decided to stay at home.

She said: "It was such an amazing match and Steven was brilliant. I was weeping, it was so emotional.

"He has lived every Liverpool fan's dream, it is a dream come true for him and for all of us. Our celebrations have only just begun."

Liverpool's air of joyous celebration was a far cry from much of the match last night when the invading Red army was subjected to a rollercoaster of emotion.

The shock of conceding the fastest European Cup final goal in history was followed the utter desolation of a three goal deficit at half time.

Then came the euphoria of Xabi Alonso's equalising goal, the unbearable tension of the penalty shoot-out and finally, disbelieving ecstasy as the cup was lifted.

The first Lewis's was opened in 1856 by entrepreneur David Lewis as a male clothing store. The following decade he branched out into womenswear, adding even more departments and expanding the empire across the country. It is believed Lewis

established the first ever Christmas Grotto at his Liverpool branch in 1879, providing thousands of children the chance to meet Father Christmas. After more than century in business its fortunes faded and the company went into liquidation in 2007.

1st March 2007, Liverpool Echo

BIG DIG BLAMED FOR LEWIS'S TROUBLES

But city chiefs say other shops are buoyant

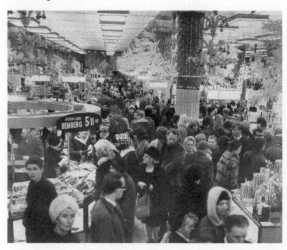

LIVERPOOL's Big Dig was today blamed for the collapse of the city's famous Lewis's department store.

The future of the 151-year-old shop in Ranelagh Street hangs in the balance after it was placed into administration, after the bank would not extend the overdraft.

Chief executive David Thompson said some of Lewis's problems were down to the Big Dig.

He said: "The market has been under pressure since the city has been dug up. We have moved from a store that made £1m profit to one that is £1m in loss.

"The Big Dig didn't help. They dug up the road outside the store, the buses no longer stopped outside our door and the street became one way."

He said that since the work was completed the customers had not returned.

Council leader Warren Bradley today said it was important shoppers show faith in Lewis's, and insisted the Big Dig was not to blame for its problems.

He said: "There is talk the Big Dig is to blame, but every other store is reporting increased footfall and profits going up.

"We must now all work together to save Lewis's for the good of Liverpool.

I will be meeting the receivers either today or tomorrow to find a way through this. The store is still trading and has not closed."

"The council has shown its faith in Lewis's before by basing the education department in one of the upper floors for five years.

Lewis's other three stores in the UK are all trading profitably. It is hoped a rescue package can be put together to save the business.

But store bosses and shop workers said today the future of Lewis's in Liverpool lies in the hands of shoppers.

A spokesman for shop workers' union Usdaw said: "Clearly Lewis's is an iconic brand within the Liverpool area and we want to get the message out that if people want to save a store then they should get in there and shop.

We believe it has a future and needs the support of Liverpool shoppers. The message is 'Use Lewis's or lose it.'

News of the business collapse was broken to the 250 staff at the store in Ranelagh Street yesterday afternoon, as insolvency experts Kroll were brought in.

Lewis's is owned by Owen Owen Holdings, which also has stores in Sunderland, Northumbria and Scotland.

Mr Thompson added: "I would like to reassure customers that it is business as usual.

I ask that customers continue to support the company to ensure this iconic business will continue in the future and preserve its local heritage."

Philip Duffy, partner at Kroll, said: "We are continuing to trade the business as a going concern while we evaluate options."

Lewis's is a member of the Liverpool Business Improvement District. Its finance and business development manager Anne Mills said today: "It is very disappointing, particularly when the retail offer in Liverpool is developing."

Ed Oliver, vice chairman of Liverpool Chamber of Commerce, said: "It is a great tragedy. Lewis's is Liverpool."

"I implore everyone to give them as much support as they can."
John Kelly, director of regeneration, Liverpool Council, said he would be meeting with Lewis's bosses.

"It is always disappointing when a major retailer gets into trouble but, overall, the evidence suggests that retail performance in Liverpool is no worse than the national average," he said.

"Some businesses are having a harder time than others, but this may be due to a number of factors in a market which is becoming increasingly competitive."

The murder of Rhys Jones caused shockwaves to ripple across the community in August 2007. Sixteen-year-old Sean Mercer was found guilty of murder and sentenced to serve a minimum of twenty-two years in prison.

23rd August 2007, Liverpool Echo

MOST SHOCKING CRIME I'VE SEEN IN 20 YEARS

MERSEYSIDE'S chief constable today said the murder of Rhys Jones was the most shocking crime he had investigated in his 20-year police career.

The 11-year-old football fan is believed to be the youngest person to be shot dead on Merseyside.

Two boys, aged 18 and 14, were being questioned today on suspicion of his murder.

Speaking to the ECHO, Bernard Howgan-Howe pleaded for help in catching Rhys's killer and those who supplied the gun.

Former Broad Square pupil Rhys was shot with a handgun in the car park of the Fir Tree Pub, Croxteth, at 7.30pm yesterday.

The Everton fan lived nearby with his parents and 17-year-old brother. He was walking home from playing football with two friends when he was shot by a hooded youth who rose past on a BMX.

People today said the schoolboy, who "never had his Everton shirt off his back", was normally given a lift home by a friend's father.

Earlier a witness told how he saw the shooting after he left the pub to smoke a cigarette outside.

"I saw a teenager on a bicycle pull up – he was 20 yards from me. I heard a bang and thought it was a firework.

Then, as we looked round, he fired two more shots at his victim.

He held both hands on the gun. He never flinched."

The 42-year-old businessman added: "The victim had on his football boots and a bag over his shoulder. He fell to the ground on his back and I ran to him. Girls were screaming. He was looking up and trying to speak but couldn't get his words out."

"His mother came to the scene, laying over him and saying, 'stay with us son'."

Today police officers stood outside the family's semi-detached home in Crompton Drive.

Mr Hogan-Howe said: "There have been two arrests overnight. But in these types of investigations it is not unusual for no charges to immediately follow.

"We need help. This is terrible and shocking, and I am horrified. We need to find out who provided the gun. There are too many guns on the street."

"Forensic inquiries are being carried out today. But it is too early to say if Rhys was being targeted."

"It has been 12 hours since the incident. People have been asleep and we have not been able to talk to all the witnesses and compare the accounts.

"What is very clear is that an 11-year-old boy went out to enjoy football, and now his poor family have had to visit him dead in hospital.

"We have been talking to people in the area and everyone is shocked. Parents must be terrified and people want the person responsible arrested. We have been acting on any intelligence provided.

What makes this shocking is the age of the victim and the fact that he comes from a good family who are entirely innocent."

"There is no suggestion that this boy was involved in criminality. We need people to come forward with any information. We won't act on a whim. If we get information we will act.

Someone somewhere knows who did this. We want to know when there is the best chance of convicting. Let's put this person before the courts.

An 11-year-old boy shouldn't die. He lived close by to where this happened. His mother was informed very quickly and went straight to be with her child. She must have been terrified at what she found.

"When an 11-year-old boy has been killed we need to stop and reflect, feel for the family and do our best to catch the people responsible.

And that means we need everyone's help. It is one of the most shocking crimes I have had to deal with. When I heard about it I came straight back to work.

That is the best indication of how seriously I felt we needed to treat this incident.

For me it is the most shocking event in my 20 years of service.

Somebody knows who shot him and who provided the weapon. We need criminal gangs to think hard about who provided the weapon. There is no shame in handing them over. We are not losing the war on gun crime. We have seen an overall reduction in the number of incidents.

We are executing three warrants a week and this week seized 50 weapons.

We are dealing with this case as the highest priority and have put 100 further officers into the investigation and more officers out on to the street.

We need to investigate this crime thoroughly and support the family through what is a terrible crime. There is no way a child should be able to walk the streets but not be able to go home."

The Bishop of Liverpool, the Rt Rev James Jones, today said it was time for the community to rally round the family of Rhys jones and help catch his killers.

"The first thoughts are with the family and how their young boy has been taken from them so suddenly and violently in broad daylight and how they will have to live with that for the rest of their lives.

They desperately need the support of the whole community.

The great thing about Liverpool is its solidarity and the remarkable way it can come round people. I'd urge anyone who has information to cooperate with the police.

The only way we can resist the fear that comes at times like this is by being together and working together to create a safe city for us all.

Parents have got to take greater responsibility for their children and young people. The gangs that exist have got to be shamed by this."

Home secretary Jacqui Smith also expressed her condolences.

She said: "I am desperately sorry for the family of Rhys – it is awful for them. I know from talking to the police that this morning that they are concentrating their efforts on this."

- Anyone with information should call Merseyside Police on 0151 709 6010 or the anonymous crimestoppers hotline on 0800 555111

One of the most memorable public displays the city has ever witnessed came in the form of a giant eight legged mechanical spider which scurried the streets in September 2008. La Machine delighted the many crowds who had turned out to see this bizarre and wonderful creation.

8th September 2008, Liverpool Echo

FAREWELL TO THE 1.8M SHOW AS SPIDER CRAWLS AWAY

By CATHERINE JONES

Culture reporter

MORE than 200,000 people converged on Liverpool to watch the giant spider prowl the city streets.

Producers of the £1.8m show, commissioned by the Culture Company, said today they were thrilled by the reaction the event had received over the past five days.

Nicky Webb, of production company Artichoke, said: "People are really proud of Liverpool, and the best thing has been looking at their faces when they see the spider – for me it makes it all worthwhile.

The massive street theatre extravaganza came to a conclusion in spectacular fashion.

Large crowds gathered to watch La Princess, as the spider was named, clamber down from her perch in Lime Street and make her escape down the Birkenhead tunnel.

But there was disappointment and some anger when thousands who went into the city centre were told the spider was not going to move until 7pm.

Meanwhile, there were scenes reminiscent of the Beatles or football homecomings as thousands thronged the city's streets on Saturday.

Around 50,000 packed the Castle Street area, Lord Street and Church Street, while thousands more filled the Derby Square where many were drenched in a water ballet.

The 37 tonne creature was met by gasps, cheers and applause as she made her way through the city centre.

But the sheer weight of numbers meant there was also some panic with people being pushed back as the 50ft mechanical arachnid, operated by her French creators, advanced on the crowds.

Liverpool One welcomed a wave of shoppers on 1 October 2008 when the billion pound shopping complex was formally opened by Princess Anne.

2nd October 2008, Liverpool ECHO

SHOPS OPEN WITH ONE SUPER SHOW

Fireworks finale to mark completion of £1bn site

The Princess Royal braved torrential rain to give the fully-open Liverpool One the royal seal of approval.

Princess Anne joined Cherie Blair's actor father Tony Booth as guest of honour at yesterday's opening of the rest of the £1bn shopping district.

Crowds braved strong and rain to watch the princess unveil an official plaque commemorating the landmark occasion.

It saw the opening of Liverpool One's leisure terrace and the transformed Chavasse Park, which overlooks the futuristically designed One Park West apartment block.

John Williams's Olympic Fanfare, played by London's Enterprise Brass, greeted the official party to the platform on the Sugarhouse Steps, which lead to the five-acre Chavasse Park.

The Duke of Westminster, whose Grosvenor firm spent £1bn creating Liverpool One, welcomed the princess, VIPs and hundreds of shoppers and visitors to the ceremony.

Struggling with a black brolly in the blustery conditions, the princess, wearing a bottle green jacket and pleated skirt, joined the crowd in laughter when the duke broke from his speech to announce: "I don't know about you, but I'm about to get soaking wet."

He thanked Grosvenor's partners, including Liverpool city council, and the public for their patience during the four-year building programme.

He said: "We thank you, the people of Liverpool, for putting up with disruption and access restrictions caused by the development. We hope you will agree it has been worth the wait."

The second phase includes a 14-screen Odeon cinema and a string of bars and restaurants overlooking the park.

Designers have even included deflectors to lift chilly gusts of wind off the River Mersey over Liverpool One.

Kensington-born Mr Booth was making his first visit to Liverpool One and said: "Liverpool always had the 'wow' factor but this just says 'wow, wow'."

Liverpool celebrated its first ever Pride Weekend In August 2010 when the city was transformed into a sea of colour and festivities.

9th August 2010, Liverpool Echo

CITY'S RAINBOW

Riot of colour as Liverpool march attracts crowds

Liverpool's first ever Pride weekend transformed the city's streets into a rainbow of colour as drag queens, samba dancers and equality campaigners marched through town.

More than 21,000 people joined the party with visitors flocking to specially-themed art exhibitions, sports tournaments and a rainbow circus in the city centre.

The festival's programme included film screenings at Fact and the Hello Sailor! exhibition at Merseyside Maritime Museum.

In Dale Street dance legend Robin S took to the main stage with former Coronation Street actor and singer Adam Ricketts.

Meanwhile Mille Dollar and burlesque friends brought a touch of old-school glamour to the cabaret stage.

Saturday's sensational parade drew 3,000-strong crowds as loud and proud lesbian, gay, bi and transsexual groups made their way from St George's Plateau to the main stage in Dale Street.

Joining them were representatives from the police, fire service, Labour party, Armistead, Age Concern, housing trusts across Merseyside and groups from many of the city's gay bars and clubs.

Today organisers proclaimed Liverpool Pride a success.

They said: "We want to highlight how proud the Liverpool Pride organisers are of the city.

"It's the first official Pride festival and we can put all the logistics in place and put the acts together. But we can't create an atmosphere.

"So it's a tribute to the people of Liverpool that the atmosphere was so fantastic."

Plans are already being drawn up for next year's event which organisers hope will be bigger and better.

It took two years of preparations and planning by the Liverpool LGBT Network to bring Pride Liverpool to life. The need for a high-profile celebration of the city's gay scene was identified as a top priority as soon as the network was formed.

After consultation with the LGBT community the festival's August date was chosen in memory of gay teenager Michael Causer who was murdered at a house party in 2008.

Jamie McLoughlin was one of the many people who turned out to celebrate diversity and equality in the city.

He said: "It was great to see Pride finally in Liverpool because it's been in so many other cities for years.

"Everybody was so friendly. Hopefully it will carry on. It was good to see bars not traditionally known as gay bars getting into the spirit – it wasn't just restricted to what's perceived to be the gay quarter."

The Museum of Liverpool was the UK's first new purpose-built museum for over a century when it welcomed visitors for the first time on 19 July 2011.

19th July 2011, Liverpool Echo

LIVERPOOL'S NEW MUSEUM THROWS OPEN ITS DOORS

by Catherine Jones

72M ATTRACTION OPENS TO THE PUBLIC TODAY

Liverpool's new museum finally opened its doors to the public today.

Lucky holders of "golden tickets" – including five Echo readers and their guests – were the first to get a glimpse inside the £72m waterfront landmark from 8.30am and a long queue formed before then.

First were Christofis and Nancy Theopanous from Mossley Hill. Mr Theopanous said: "How many times do you get invited to the opening of a new museum?"

The Museum of Liverpool, the largest new-ly-built national museum in the UK for more than a century, was being offi-cially opened by National Museums Liverpool chair-man Phil Redmond, direc-tor Dr David Fleming, and by six-year-old city school boy Finn O'Hare, who wrote to NML asking if he could cut the ceremonial ribbon.

Phil Redmond said: "It's fitting that in Finn we have a regular Liverpool lad helping out at such a pivotal event in our city's history.

"**This museum is not just about Liverpool** which we all know in this room is the creative centre of the universe, but about Liverpool's place in the UK and the UK's history. And it is a very important place."

Museums staff yesterday were busy putting the fin-ishing touches to the inte-rior of the site including The Beatles immersive and footballing film in the sec-ond-floor Wondrous Place gallery.

The gallery is one of five – Wondrous Place, People's Republic, Global City, Little Liverpool and the Skylight gallery – being opened today.

A second phase, taking in the Great Port gallery, Overhead Railway, City Soldiers and History Detectives sections of the museum, will open in the autumn.

Dr Fleming said: "Our ambition for the Museum of Liverpool was to create the world's greatest urban history museum.

"For the past 10 years, our team has worked tirelessly, with a great deal of help from the public, to channel this ambition and develop a museum which explains Liverpool using objects to illustrate its story.

"Liverpool is very easily misunderstood, not least because in living memory it has been a poor city, plagued by unemployment and poverty.

"But less than 100 years ago, Liverpool was one of the greatest cities on earth, and only through knowing this, and understanding why this was can anyone understand the modern city."

Funding for the new building came from the Northwest Regional Development Agency (NWDA), Heritage Lottery Fund (HLF), Department for Culture, Media and Sport (DCMS), European Regional Development Fund (ERDF) and £1m from the Garfield Weston Foundation.

NWDA chairman Robert Hough said: "The rejuvenation of Liverpool's world-famous water-front is a major part of the legacy the NWDA leaves for this city and the region.

"The museum is a great and fitting representation of Liverpool's identity as a cultural mecca, celebrating the city's past and looking towards a bright future."

Exhibits on show range from a scale recreation of an 18ft Liver Bird statue and cycle legend Chris Boardman's famous Lotus Sport bike to the stage where Lennon and McCartney first met in 1957, and a new atrium artwork created by youngsters from the Redi Extra project, based in Bootle, and artist Faith Bebbington, and sponsored by Echo in the Community.

Amy Norcross, 13, from Bootle said: "It looks amazing."

The new museum will be open daily from 10am to 5pm, and is free.

Liverpool got the media's attention once again by choosing to appoint a directly elected Mayor. Joe Anderson took office in May 2012 to begin a four year term of office.

4th May 2012, Liverpool Echo

JOE ROMPS HOME

Labour leader takes 57% in historic vote

Joe Anderson is today Liverpool's first directly elected mayor, after enjoying a decisive victory with 57% of votes in the historic poll.

He was declared the winner at 4.10am at the Liverpool Tennis Centre in Wavertree, polling 58,450 votes amid jubilant scenes from Labour supporters.

Mr Anderson will govern Liverpool for the next four years and is the most powerful politician in England outside of London.

In total 101,301 voted in the mayor's election, a turnout of just 31.2%.

Independent Liam Fogarty grabbed second with 8,292 votes while Liberal Democrat Richard Kemp came in third with 6,238.

Mayor Anderson said: "I promise that our message to you is that we will deliver on our pledges and our promises. The people of this city need new housing, new jobs and new schools. That is what will be delivered by an administration with a Labour mayor."

Changing the city's electoral system has represented the biggest gamble in the political career of Mr Anderson, who has been council leader for the past two years.

Ditching the role of council leader and having a mayor instead was linked to the government's city deal, which will see an additional £130m handed to the city.

He ran a campaign built around the deal that had three key promises: to deliver 5,000 new homes, 20,000 new jobs, and 12 new schools during his four year term.

The salary for the new mayor will be set by an independent panel and will be voted on by the council later in the month.

Mayor Anderson was forced to deliver his victory speech over loud heckling and chants from a handful of far right activists.

But he declared: "The future of this city is a bright one. It is not represented by fascists, they are people that do not represent this city. We will democratically defeat these fascists at the ballot box every time. That's why they shout loudly now because people in this city have told them loud and clear to get stuffed." His victory triggers a summer by-election in his Riverside seat, which he has to vacate.

Mr Forgarty said he was humbled to score second place.

He said: "It's been an exciting, satisfying and humbling experience. When you are up against some very well established parties, with the organisation, resources and boots on the ground it's always going to be a scrappy, outsiders campaign.

"I am really pleased for the people who have taken part in it for me, that have made it happen, the people that have put out the leaflets and used social media for my campaign. I have emerged with a new respect for people who do this for a living."

All eyes were on local student Beth Tweddle as she secured a bronze medal at the London Olympics in 2012. She graduated from Liverpool John Moores University with a degree in Sport and Exercise Science and was granted an Honorary Fellowship by the institution for her achievements.

7th August 2012, Liverpool Echo

AT LAST! MEDAL JOY FOR GYMNAST BETH

City athlete scoops Olympic bronze at third attempt

Liverpool trained gymnast Beth Tweddle was just a step away from being crowned Olympic champion to round off her stellar career.

The 27-year-old has put in thousands of hours at the City of Liverpool club in Toxteth since she was 11 and lined up in yesterday's Uneven Bars final one of the strongest in a field of eight.

But a stumble on her dismount cost her the top

spot, according to gymnastics coach Gary Kirkby, who was watching in the hall where the two-time world champion honed her skills and still uses as a training base.

But she was still the pride of the club as she claimed her first Olympic medal, the only thing missing from her collection.

She said: "It means everything. I just wanted to win a medal, it didn't matter what colour.

"It's the best feeling in the world. Everyone knew coming into these championships it was the one medal missing from my collection.

"I always said I didn't care what colour it is. Bronze – I'm made up with it.

Mr Kirby, the gymnastics development officer for Liverpool City Council, told the ECHO: "What Beth has achieved is fantastic, she has an Olympic medal.

"We are absolutely proud of her performance.

"A small fault right at the end of her tremendous routine cost her, but she'll be pleased, and as ever she will smile and congratulate the other competitors."

He praised Beth's "commitment and determination" and also the contributions of the coaching staff.

There was a roar as "Elizabeth Tweddle, representing Great Britain", was announced.

She was fourth in the running order and wowed with a stunning routine of ambitious leaps and complex twists all executed with precision.

But as hse dismounted slightly off-balance and stumbled, her chances of the all but dashed.

Mr Kirby said he hopes Beth, in the twilight of her career and nicknamed the grandmother of her sport, will continue to have an association with city club.

He added: "She needs to have a rest now after doing this for so many years, but she is always welcome here.

"Everybody trains together, so the younger ones have been watching and been inspired by her for years, and she always gives advice and encouragement."

Congratulations for Beth also came from Liverpool Mayor Joe Anderson and city's Lord Mayor Cllr Sharon Sullivan, who said "Beth Tweddle is a true inspiration for young people across the nation.

"The whole city is so proud of her for achieving Olympic success."

Cains Brewery had been established in 1858. Within twenty-five years of founding his brewery Robert Cain had established 200 pubs, including the amazing Philharmonic Dining Rooms. In May 2013, Cains announced it had ceased brewing altogether but has hopes for a resurgence.

13th May 2013, Liverpool Echo

CAINS STAFF MEET UNION

Officials to visit brewery after axe shock

Union officials will visit Cains today to meet staff who lost their jobs after the company suspended its brewing operations.

Cains announced on Friday it was closing its loss-making supermarket own-label brewing and canning operation and axing 38 jobs.

The company, run by brothers Sudarghara and Ajmail Dusanj, has also started negotiations to sub-contract the brewing of Cains' beers to a third party.

Franny Joyce, regional officer for Unite, is to meet affected workers to discuss what action they can take. Just 18 remain at the site.

Production of beer at Cains' landmark Stanhope Street site, off Parliament Street, stopped the week before last.

Cains say production will only resume if it wins permission to develop the site into a £50m "brewery village".

The plans, revealed in the ECHO last month, would see the Grade II-listed redbrick original brewery building refurbished to house a craft brewery, a hotel, shops and a "delicatessen-type" food hall. A sky bar would also be installed on the roof.

The production sheds that face Parliament Street would be replaced by a supermarket with apartments on top.

Cains will submit its plans to Liverpool City Council this summer. If approved, work could start next year – but would take up to two years to complete.

On Friday, a Cains spokesman told the ECHO: "Brewing at the site has been suspended while we progress our Brewery Village scheme and we are in negotiations to sub-contract the brewing of Cains products to a third-party brewery during this interim period.

"The nature of our brewery is such that its operation cannot be scaled down in a simple fashion and it would be financial madness to continue with such huge overheads for a relatively small brewing operations."

He added: "We have said all along that the brewery is at the heart of our plans for the Brewery Village scheme and this remains the case.

"The existing brewery will be redesigned during the anticipated redevelopment so that it is more efficient and better suited for future use.

"We are continuing to discuss matters with our advisors about how we best manage winding up the current canning and brewery side of the business.

"Cains is alive and kicking and we are extremely positive about our future plans."

Fans of This Morning saw the welcome return of the giant weather map to the Albert Dock as part of a special edition of the programme on 3 October 2013.

3rd October 2013

RETURN OF THE MAP

Today see the return to Liverpool of the iconic TV show This Morning – and with it that famous weather map.

The flagship daytime show is celebrating its 25th anniversary with a special one-off show from its original home on the Albert Dock.

Richard Madeley and Judy Finnigan will be back on screen, alongside current hosts Phillip Schofield, Holly Willoughby, Eamonn Homes and Ruth Langford.

The two-hour live programme means the floating map has been brought back for the occasion – with prankster Keith Lemon taking over meteorological duties from Fred Talbot.

Producers have promised mixture of surprises and guest appearances.

Richard said: "I don't want to say what, but we do have a stunt up our sleeves that I hope will raise a smile.

"We are incredibly excited to be coming back to Liverpool. We have such fond memories of being in the city and all the people we met. We were so sad to leave to go to London.

"It is a pleasure to be asked back. Judy and I have visited a few times and I always find myself peering in through the windows of the café where the old studio used to be, working out where the sofas were.

"It's going to be like stepping back in time. I can't wait to be back among so many friends."

Phillip added: "Richard and Judy started the show and now for us to be in charge of it and seeing it through the 25th anniversary – which I never would have believed would have happened when it first began – is a real treat."

Holly said: "25 years is such an incredible achievement I never thought I would be on the show when I watched it when I was younger. But I am so proud to be working on This Morning.

"We cover so many varied subjects and if I wasn't doing the show, I would be watching it. I feel guilty calling it a job because it is so enjoyable."

In July 2004 Liverpool became Lilliput as a trio of towering giants explored the city aided by a team of talented puppeteers. The special event was staged to mark the centenary of the First World War.

22nd July 2014, Liverpool Echo

ONE GIRL AND HER DOG

By Catherine Jones

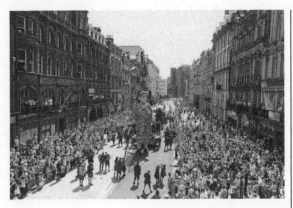

This Friday means one thing and one thing only... the day has finally dawned, and the Giants are on the move.

While the Grandmother of Liverpool will have been on public display for two days, asleep in St George's Hall, Friday is the first chance to catch up with the city's old friends, the Little Girl and her mischievous giant pet dog Xolo.

It will be the first time the pair will have been seen in public here since they sailed down the River Mersey two years ago after their 'Sea Odyssey' to mark the centenary of the Titanic.

Now, two years on, they are returning to help the city commemorate another centenary – 100 years since the outbreak of World War I.

The Little Girl and Xolo will start their day with a wake-up call **at the entrance to the Queensway Tunnel at 10.30am.**

Once their morning routine is completed, they will make their way along Old Haymarket and up St John's Lane, looping around the Marriott hotel and into Roe Street and Queen Square Bus Station, and then on to Whitechapel.

From there they will walk all the way through the city centre, traversing Church Street and heading down Paradise Street, then turning left into Hanover Street, Ranelagh Street, Great Charlotte Street and Elliot Street – facing St Johns Shopping Centre.

Moving on to Lime Street, they will then start the climb up Renshaw Street and Berry Street arriving at Chinese Arch at

around 1.30pm where they will have a siesta.

Meanwhile the Grandmother, wide awake now after her slumber in St George's Hall, will wake and leave the hall at 11am via Lime Street.

She will first make her way down William Brown Street, past the library and museums, to the Queensway Tunnel entrance.

Continuing down Victoria Street, she turns left on to North John Street, right up Lord Street and right again on to Castle Street.

At the Town Hall she will turn left down Water Street, joining The Strand, and arriving at Salthouse Dock at 1.30pm for a snooze.

She's 85 but she's feisty and raring to go. Grandmother will be ready to leave Salthouse Dock at 4.30pm, heading down The Strand to Paradise Street, then on to Hanover Street, Lime Street, Great Charlotte Street, Mount Pleasant and Brownlow Hill, heading out of town.

Her route takes her via Minshull Street and Low Hill to Kensington, Sheil Road, on to Gardner's Drive, arriving first in Newsham Park at 7.30pm.

Then at 5pm, the Little Girl and Xolo will be ready for their next adventure, leaving the Chinese Arch and walking up Upper Duke Street, Canning Street and past Falkner Square, also leaving the city centre.

Their route takes them along Grove Street and then Oxford Street, Grinfield Street, Harbord Street and then turning on to Durning Road, Holt Road, Kensington, down Sheil Road, on to Gardner's Drive, and Newsham Park to meet The Grandmother.

The Everyman Theatre was founded in 1964 and has become one of the nation's leading performance venues. They theatre was completely rebuilt in March 2014 and awarded the RIBA Stirling Prize, the first theatre in the county to be granted the accolade.

3rd March 2014, Liverpool Echo

NEW EVERYMAN TAKES THE CENTRE STAGE IN WEEKEND OF EVENTS

More than 4,000 theatre fans queued to be first to see inside.

Theatregoers queued around the block to be the first to see inside the new Everyman.

More than 100 people were waiting when staff opened the doors for the first time at 11am yesterday.

Crowds packed the theatre throughout the day with more than 4,000 coming through the doors between 11am and 5pm.

Tours of the front and backstage area were held every 15 minutes and hundreds of others took the chance to have drink in the bar, stand on the new balcony, eat in the Bistro or sit in seats in the new auditorium.

Cathy and Steve Bass, from Formby, who had their first date at the Everyman in 1977, were among those taking a look inside.

Steve said: "The play was Flying Blind, and in the first five minutes the leading actor and actress took off all their clothes."

Cathy added: "We were on the front row. And I thought, 'What does he think I'm like? I'm a good Catholic girl'!"

Students at Hillside High, in Bootle, had also come to see the theatre whose history is the subject of a special GCSE project.

Head of performing arts Carmel Carey-Shields said: "I used to sit next to Pete Postlethwaite, Julie Walters and Bill Nighy in the Bistro downstairs.

"As a school, we've watched this go from what

it used to be to now, and it's superb."

Everyman executive director Deborah Aydon said: "It's overwhelming. Everyone is coming in and just beaming."

And artistic director Gemma Bodinetz added: "It's just so beautiful to see it full of people after years and years of dreaming of this moment."

Meanwhile, hundreds of people gathered at the corner of Hope Street on Saturday evening for the Lights Up parade and opening ceremony. Film footage of actors and writers sending their best wishes was beamed on to a giant screen.

Actor Tom Georgeson described the theatre as "warm, affable, witty and

inspiring", while poet and playwright Roger McGough joked that the new venue had "Gone all posh ... in a Liverpool sort of a way".

Chris Axworthy, from Aigburth, a former Everyman Youth Theatre member, added: "Someone said 'It's only a building' and I said, 'It's far more than that. That's my life'."

The International Festive of Business brought the spotlight back to Liverpool, this time when the city showcased its commercial prowess to business leaders from across the world.

10th June 2014, Liverpool Echo

EYES OF WORLD FOCUS ON CITY FOR FESTIVAL

LIVERPOOL yesterday put themselves at the heart of the UK's economic revival as the country's top political and business leaders gathered in the city for the launch of the International Festival for Business (IFB) 2014.

Amid the splendour of St George's Hall and,

speakers including Prime Minister David Cameron, Liverpool Mayor Joe Anderson and ex-Minister for Merseyside, Lord Hestletine, launched what is being hailed as the biggest showcase for British industry since the Festival of Britain in 1951.

Leading business figures also addressed the British Business Embassy event, including former Tesco chief executive, Sir Terry Leahy, and Ana Botin, the boss of banking giant Santander.

The main hall also formed featured examples of great British manufacturing including Air-bus and Jaguar Land Rover.

IFB will last for 50 days and will comprise more than 300 events – most in Liverpool and with others in Warrington and Manchester.

Around 250,000 people from more than 100 countries are expect to flock

to the region during June and July.

The ECHO revealed a few weeks ago that more than £1.7 billion business leads will be up for grabs during the festival.

The main two aims of IFB are to double UK exports by 2020 and attract an extra £100m of foreign direct investment into Britain between now and 2019.

Mayor Anderson told those assembled that 'Liverpool's best years are still ahead'.

Liverpool, he said, is hosting the biggest business event in the world this year and he added: 'I am very proud of this.

Despite the challenges we have faced, Liverpool is a city that is looking for new opportunities – opportunities that we can grasp with both hands.

We have an open mind, we think differently and we are prepared to do things differently.

There is a JFK quote on my office wall, "conformity is the jailer of freedom and the enemy of growth", and in Liverpool we take that to heart because we are breaking down old ways of thinking.

In doing so, I believe we have created the determination to get through the tough times and to grow our economy by being imaginative and creative.

As I speak, more than £1bn is being spent on regeneration by the private sector in the city. Liverpool is full of confidence and is an exciting place to be.

Like other cities, our recovery is still fragile and needs to be nurtured, but we are finding new ways of moving forward.

IFB will be something the UK has not been seen for decades. We can achieve great things.'

Merseyside Champion, Lord Hestletine, spoke of his excitement as he watched IFB get under way.

Having a giant business expo in the city was the brainchild of the former Minster for Merseyside and Sir Terry Leahy, and in an interview with the ECHO he said he was delighted to see that idea become a reality.

Hezza came to Liverpool in 1981 and in the wake of the Toxteth riots – a time when many of his Whitehall colleagues were ready to write the city off.

He brought together the public and private sectors in a huge regeneration effort.

Yesterday, Lord Hestletine told the ECHO there was much to be proud of during the last 30 years and he now had great optimism for the future of the city.

'I find it so exciting. Above all because it shows what can happen over the next 30 years,' he said.

'There is now such a basis of optimism – so many people committed to making it successful – such an achievement in so many different fields that this place is now on a high. There is a long way to go and there are lots of areas that need tackling but you now believe in it.'

Prime Minister David Cameron said the IFB was set to be a key driver of the UK's 'economic revival'.

Mr Cameron said he hoped IFB would help bring investment to 'this fabulous North West region and this iconic city of Liverpool'.

'I have been associated with the festival right from the start. I think it is a great idea and full credit to everyone in Liverpool and on Merseyside who have been involved in bringing this together.'

Huge crowds turned out along the Pier Head and across the water to watch Cunard's Three Queens sail into Merseyside to honour of the company's 175th year anniversary. The Queen Mary II, Queen Elizabeth and Queen Victoria performed a synchronised turn in the river wowing spectators young and old.

26th May 2015

Three Queens In Liverpool 2015

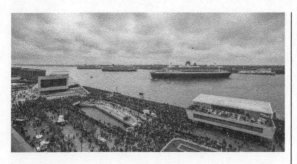

As many as 1.4m people are believed to have flocked to the banks of the Mersey to watch the historic Three Queens celebrations.

Official figures aren't likely to be available until at least today.

But yesterday Mayor of Liverpool Joe Anderson told the ECHO: "People are talking about 1.4m visiting and seeing the sights across the river, in Liverpool, Wirral and Sefton.

"The city has been buzzing.

"And of course, one million came to see the QE2."

He added: **"It's been absolutely fantastic. Today really does high-light what we've said about the city's relationship with the sea, and especially Cunard.**

"I don't think there's any company that has more of a place in our hearts in this city than Cunard. The amount of people who came out proves that."

Meanwhile, Commodore of the Cunard fleet, Christopher Rynd, said:

"It's been a privilege to bring the Cunard fleet together on the Mersey for the first time ever to mark Cunard's 175th anniversary year and our historic and ongoing partnership with Liverpool, our spiritual home.

"The spectators have been amazing and the numbers extraordinary – all the way from the mouth of the Mersey to the Pier Head, we've seen such enthusiastic crowds.

"There's an emotional connection between us. Cunard is more than just a shipping line – it's a source of pride that means so much to us and everyone associated with it.

"It's a real pleasure to be able to celebrate that enduring bond between us all in such a special way."

Huge crowds started to gather on the Liverpool, Wirral and Sefton waterfronts from early yesterday morning.

People flocked to Crosby and New Brighton

to catch the first sight of all three ships together, after the QM2 slipped her moorings and sailed down the river at 10.45am to meet her sister Queens.

Early visitors to the Pier Head were treated to a concert from the steps of the Cunard Building featuring the Liverpool Welsh Choral, Band of the Marines, soprano Danielle Thomas and a bagpiper.

By the time the QM2 returned shortly after noon, sailing at the rear of a regal convoy, the numbers on both sides of the river had reached maximum point. Several of the five viewing areas on the Liverpool waterfront were closed after they became full.

Massive numbers also brought transport congestion for a time, particularly in the two hours following the river spectacular, with tens of thousands of people trying to leave the city centre at the same time leading to gridlock on roads and queues stretching for hundreds of metres outside railway stations.

The day ended with the third performance in as many evenings of the Amazing Graces projection on the Three Graces, and a firework display as the Queen Elizabeth sailed out of the river.